SECONDHAND

AUGUST 4, 2014–MAY 31, 2015

PIER 24 PHOTOGRAPHY

Located on San Francisco's Embarcadero, Pier 24 Photography offers a venue to experience and quietly contemplate photography. In addition to presenting ongoing exhibitions, publications, and public programs, Pier 24 Photography houses the permanent photography collection of the Pilara Foundation.

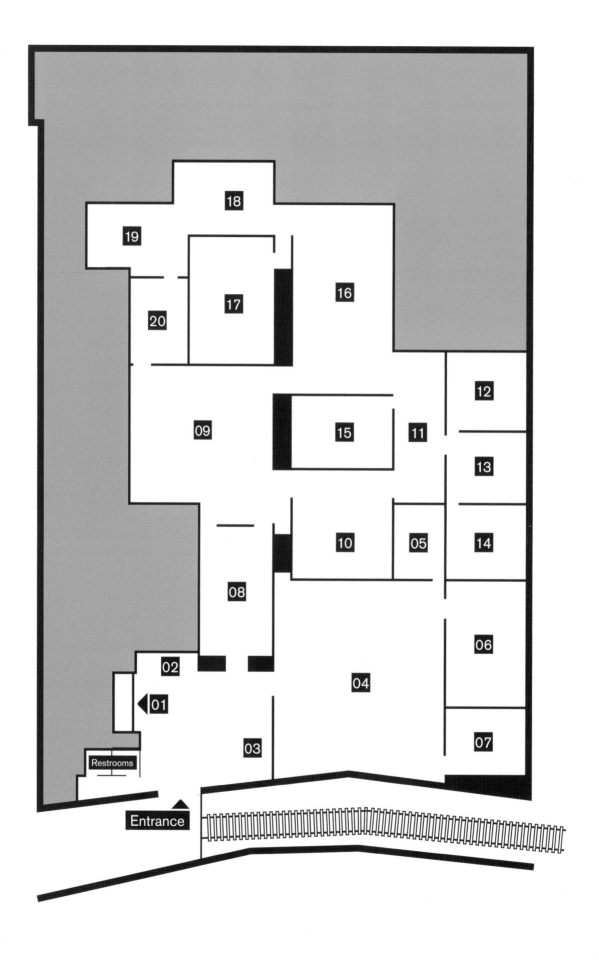

SECONDHAND

The digital age has ushered in a culture of curating. Blogs, along with websites like Instagram, Facebook, Pinterest, and Flickr, enable users to not only produce and disseminate unique content, but also to communicate through the editing, sequencing, and selection of existing material. These online platforms have become a way of digesting and understanding the overabundance of visual information circulating daily. As a result, the definition of the term *curator* has expanded beyond the realm of highly educated art historians to include anyone engaged with organizing content. It is no surprise that this curatorial impulse appears in the practices of many contemporary artists, where the distinction between curator and creator has become less defined.

The sixth exhibition at Pier 24 Photography, *Secondhand* features artists who build repositories of found images, from which they appropriate, construct, edit, and sequence in order to create something entirely new. Through this process, their distinctly personal approaches become as wide-ranging as their source material. These works are paired with selected vernacular photographs from the Pilara Foundation collection, illustrating another instance in which found pictures can offer new meaning through a simple change of context.

The pioneering artists Richard Prince (gallery 01), John Baldessari (gallery 03), and Larry Sultan and Mike Mandel (gallery 15) began sourcing images from popular culture and government archives in the 1970s and 1980s. Removed from their original contexts, these pictures offer new insight, encouraging viewers to reexamine their relationship to commonplace imagery, while also considering the notion of authorship. The precedent set by these artists empowered the next generation to sample, dissect, and reimagine without hesitation, using any available image to create new works of art.

Erik Kessels, whose work is featured here in several large galleries, epitomizes the fluidity of the roles of curator and creator. Kessels has amassed an immense archive of vernacular snapshots and photo albums that he incorporates into his artistic practice. In *Album Beauty* (gallery 09) and *in almost every picture* (gallery 04 and 05) he curates from his holdings to suggest universal connections between found images, which, as a result, transcend their personal subject matter. Viewed through his lens, Kessels's selections speak to the human experience and nod to the power, beauty, and materiality of these amateur pictures at a time when images are largely consumed online. In *24 HRS in Photos* (gallery 17) he comments directly on the photograph's role in the digital world by printing every picture that had been uploaded over the course of one day to the photo-sharing website Flickr. Through this installation, the viewer can both visually and physically experience the overwhelming number of photographs shared online.

Matt Lipps (gallery 06) selects, arranges, and rephotographs cutouts from the now defunct American lifestyle magazine *Horizon*, constructing works that contemplate how our understanding of culture is mediated

through our relationship to images. Hank Willis Thomas (gallery 08) appropriates culturally charged historical images, presenting them in memorial flag frames that trigger ideas about collective commemoration and cultural remembrance.

The Internet operates as an archive of source material for several of the photographers in the exhibition. Daniel Gordon's (gallery 11) vibrant still lifes are carefully constructed from ripped and recombined photographs the artist found online. Similarly, Rashid Rana (gallery 16) blends thousands of online images of unrest and protest to create an overwhelming crowd scene that engulfs the viewer. From her studio in Berlin, Viktoria Binschtok (gallery 20) scours the expansive archives of Google Street View for scenes of New York. She then travels to these locations and produces new photographs, ultimately presenting her pictures and the source images together.

Drawing from vast collections of photographs, Melissa Catanese (gallery 18) and the Archive of Modern Conflict (galleries 12–14) blur the lines between curating and creating, revealing how unpredictable narratives and associations can emerge through deliberate editing and recontextualization while offering a perspective that is distinctly their own. Throughout the exhibition, selected vernacular images from the Pilara Foundation collection are presented in a similar manner. Through their juxtaposition with contemporary works of art, these commonplace pictures of the past move beyond their original purpose and intent to engage us in new ways.

For instance, the group of early twentieth-century press photographs of baseball players illustrate the elaborate artistry of analog photo-editing techniques. And the significant grouping of mid-century American employee badges speaks to the nation's rise to industrial prominence while also addressing each subject's individual experience and the close link between personal identity and professional life.

At a moment when the medium is undergoing significant changes, the desire to reexamine what photography has already accomplished is strong. So what are the image-makers brought together in this exhibition doing to advance the language of photography? With more than one hundred and fifty years of printed photographs at their disposal, along with the millions of digital pictures uploaded daily, these artists are uniquely positioned to critically examine the role of images in our society. While mining these found images to reveal their own perspectives, the defining features of their artistic voices become process, craft, and display. A refined engagement with the history of art also contributes to the exhibited artists' ability to convey an articulate message with the overabundance of visual material that surrounds us. The works presented in *Secondhand* resonate with the current state of our visual culture and our society's obsession with access, illustrating the creative potential intrinsic to the sharing and curating of images and ideas.

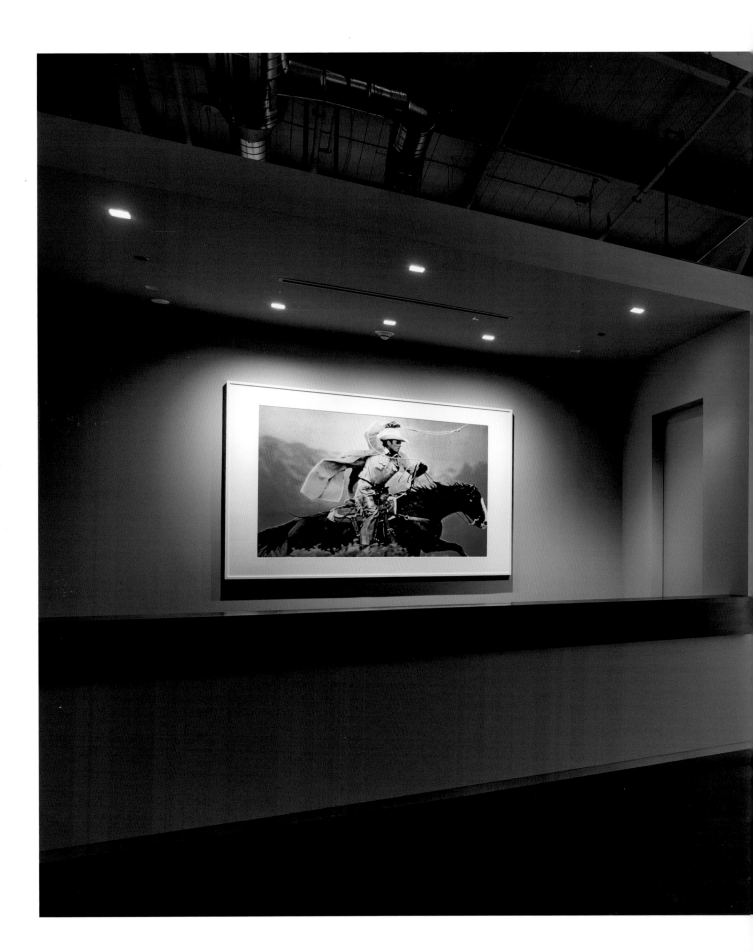

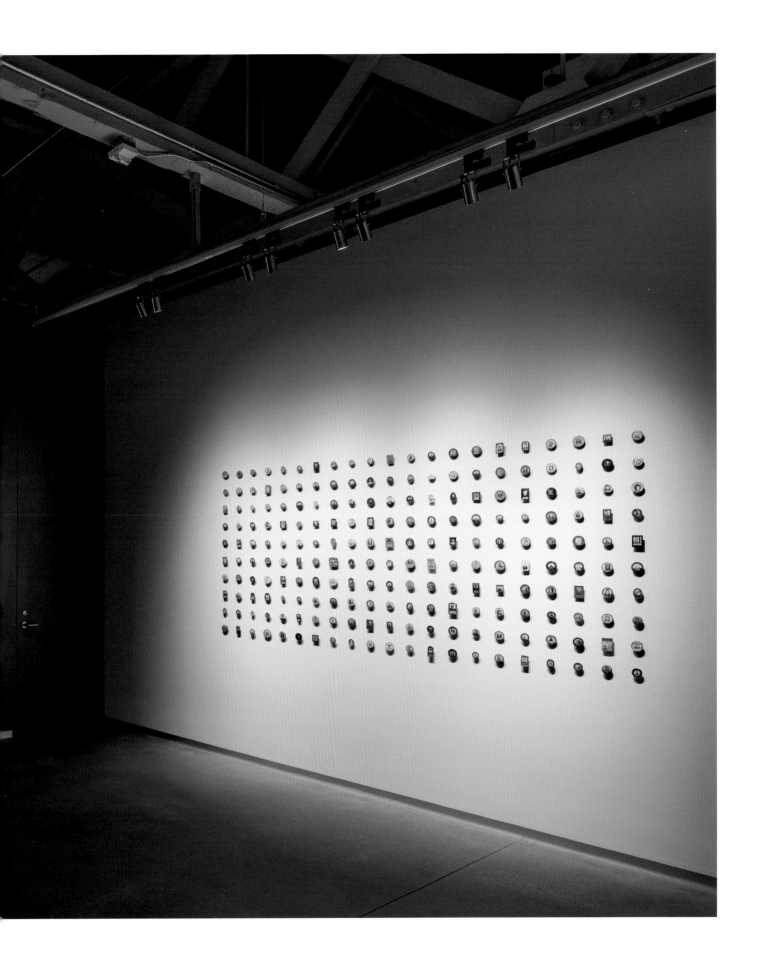

Richard Prince, *Untitled (Cowboy)*, 1991–92

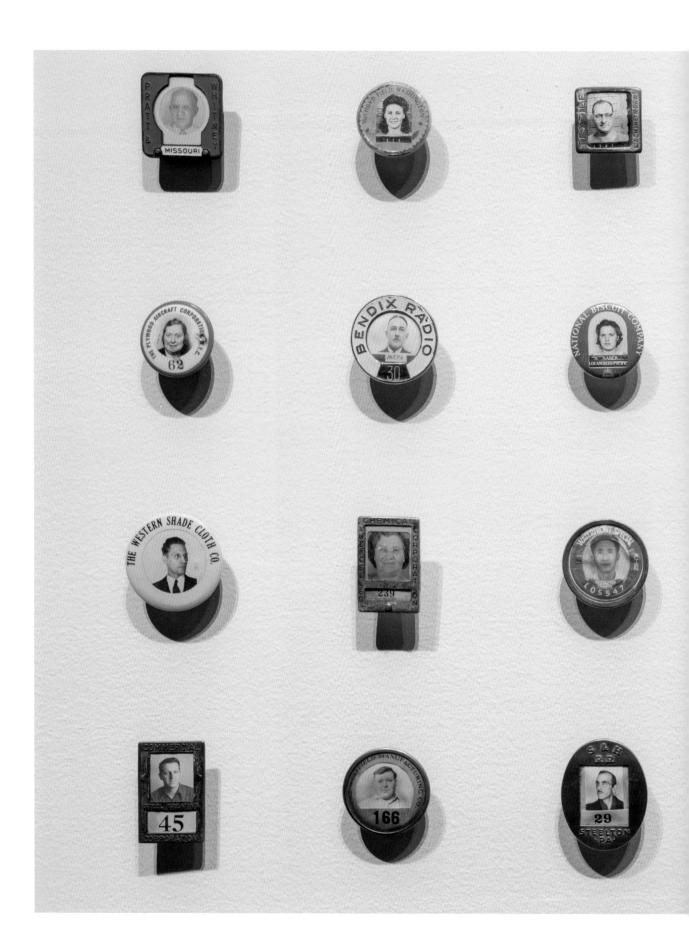

Unknown photographers, Employee badges, 1920s–1960s

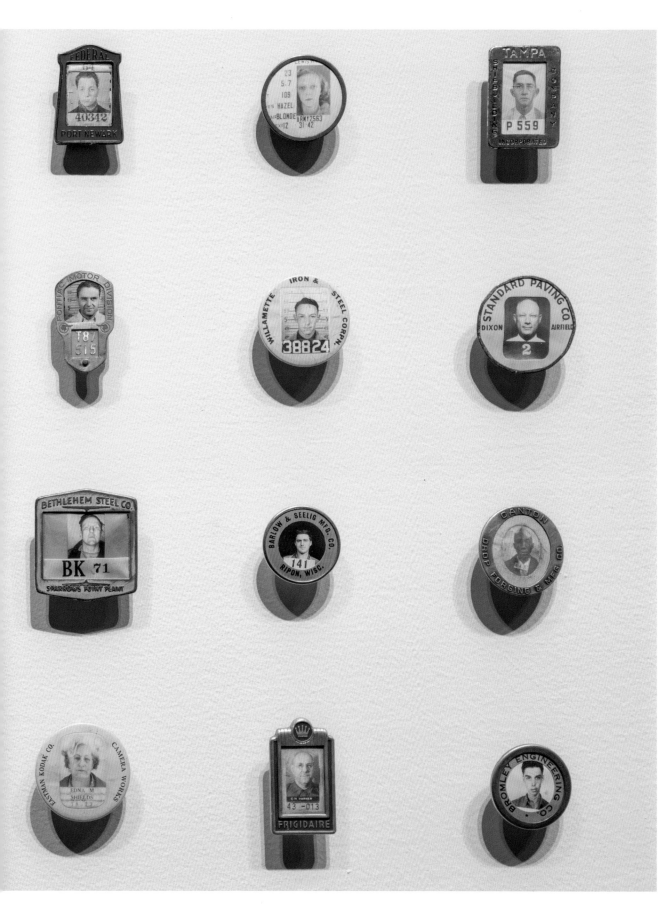

I really don't think imagery should be owned, including my own. If it's part of our world, it's like owning words. How can you own words? It's just stuff to use.

John Baldessari

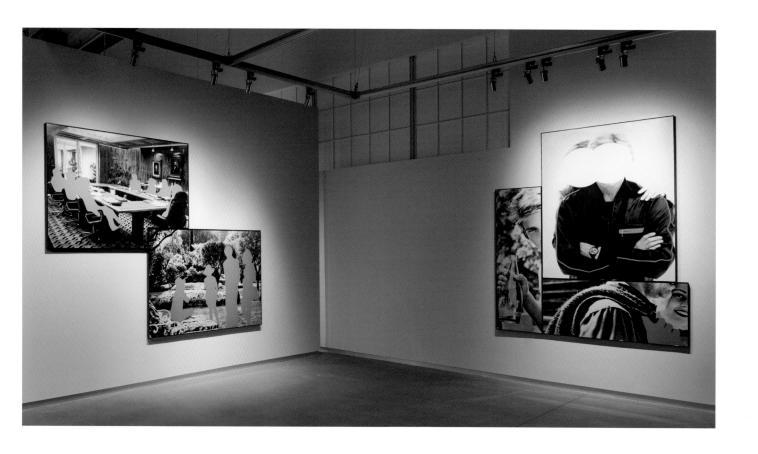

Left to right:
John Baldessari
Two Groups (One Warm/One Cool), 1990
Perrier (with Figures), 1990

Erik Kessels, installation view featuring *in almost every picture*, 2002–10, and *Photo Cubes*, 2007

The simple idea of the *in almost every picture* series is so engaging and diverse. It plays on our desire to look at others' memories; it is through the lives of others that we live our own. There is a fascination with looking through photo albums and the boxes of old photos at charity shops in a similar way to browsing Flickr and Facebook albums. It's not only the voyeur in us or the desire for people-watching. The anonymity of the images prompts us to interrogate and create narratives about the lives and places we see in the photographs. When was it taken, what were they doing and why, and what remains after the originators pass away into the gray area of history are endless open endings that encourage us to imagine.

Louise Clements

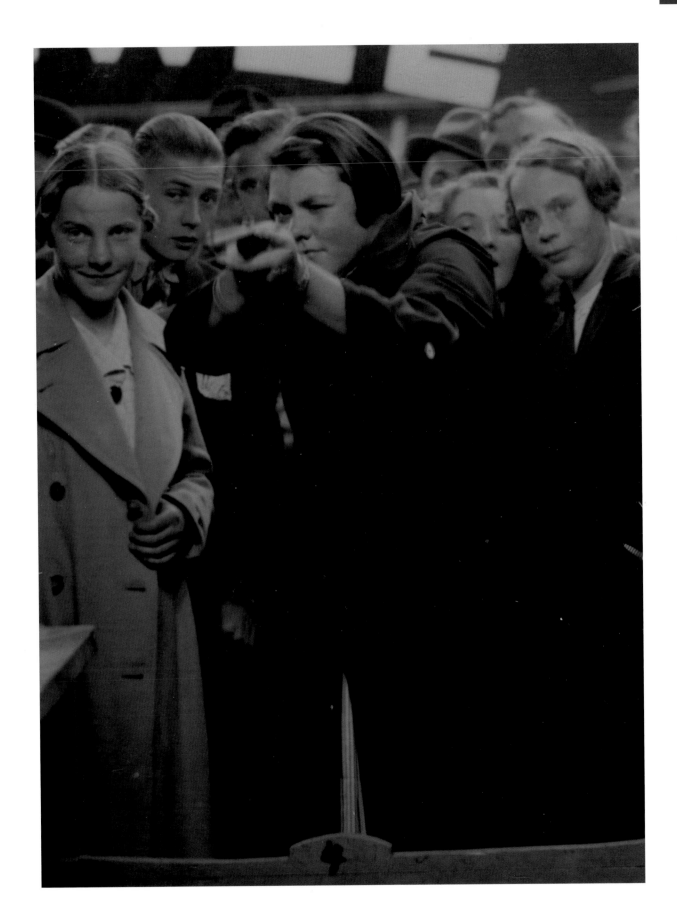

Erik Kessels, *in almost every picture #7*, 2008

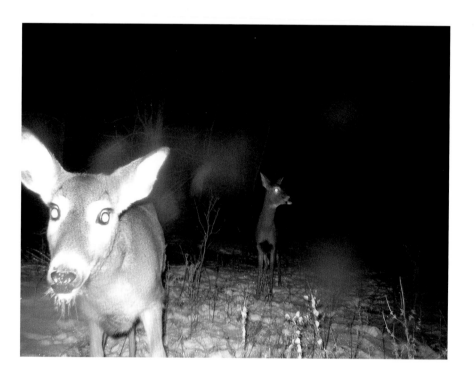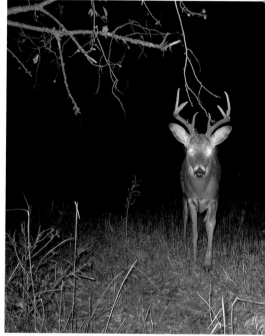

Erik Kessels, *in almost every picture #3*, 2005

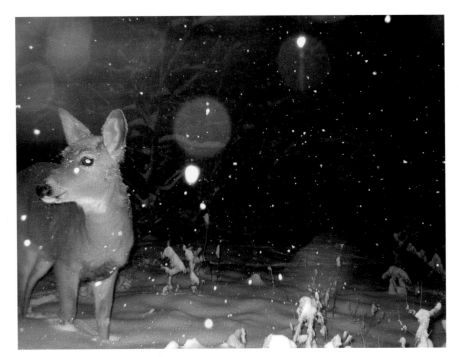

Captured by a motion-activated camera, these pictures feature portraits of deer in the deep forest. The images, which were found on a prominent hunting website, bring us face-to-face with animals in their natural environment, unaware of any human presence.

Erik Kessels

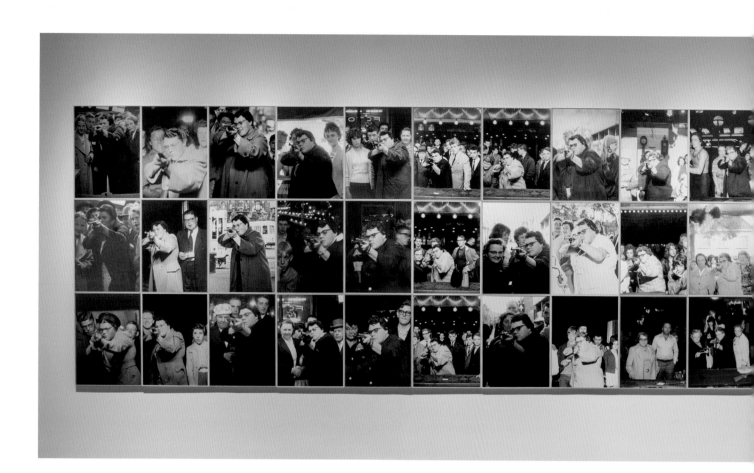

Erik Kessels, *in almost every picture #7,* 2008

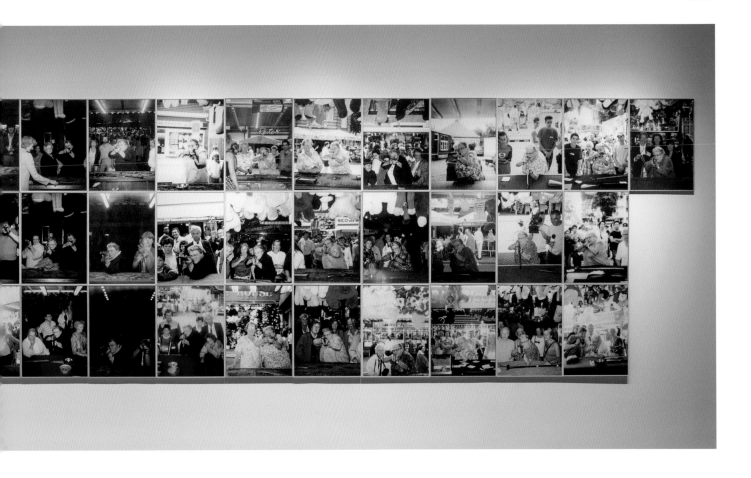

This chronological series documents almost every year of its subject's life, from 1936 to the present, with the exception of a conspicuous pause during World War II (1939–45). The year the pictures began, she was a sixteen-year-old girl from Tilburg, Netherlands. The pictures were taken in a carnival shooting gallery. Every time she hit the bull's-eye, the shutter of a camera was triggered, taking her portrait in firing pose, which she received as a prize.

Erik Kessels

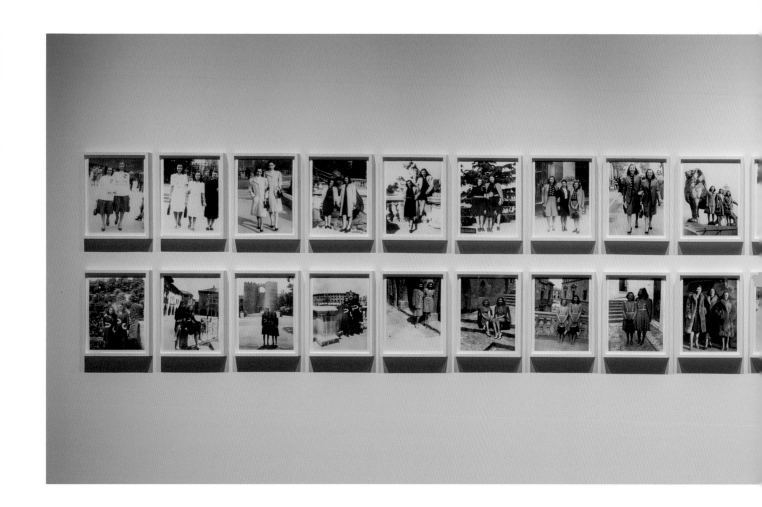

Erik Kessels, *in almost every picture #4*, 2005

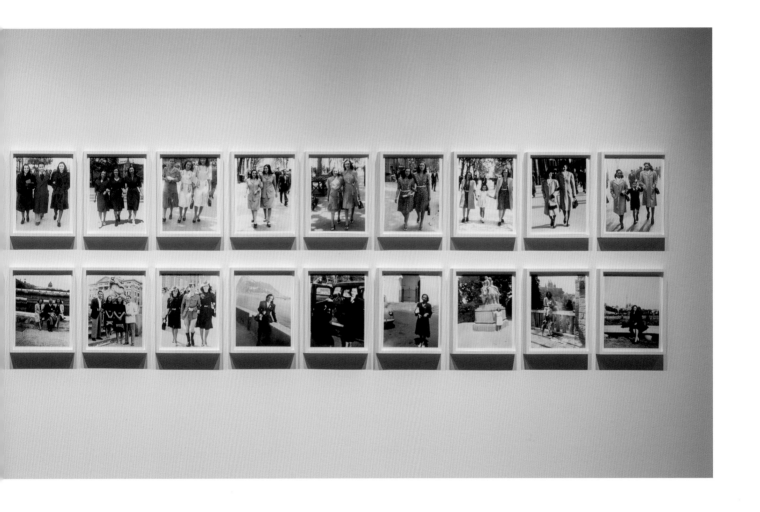

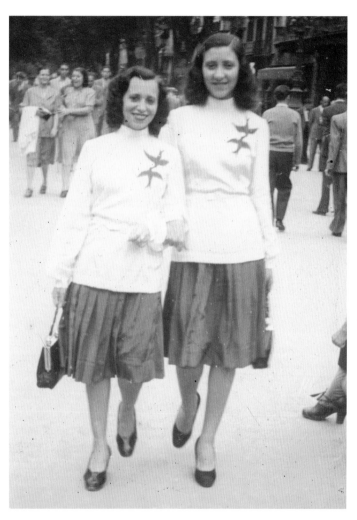 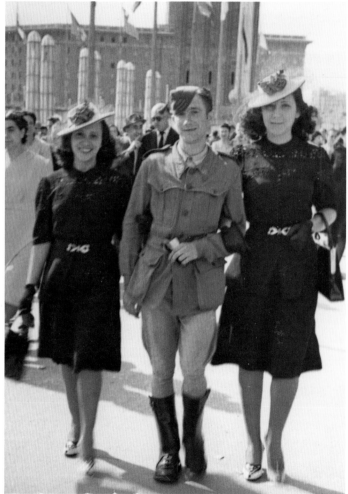

Erik Kessels, *in almost every picture #4*, 2005

This series features two sisters—fraternal twins who take extra care in their styling and wardrobe to appear more identical. For a few short years they were professionally photographed on the promenade in Barcelona. At a certain moment the tragedy of World War II invades these delicate and wonderful pictures, as we see that one of the twins is missing in the final photographs, taken before the end of the war. The surviving twin, as if by instinct, continues to leave room for her sister in the remaining pictures.

Erik Kessels

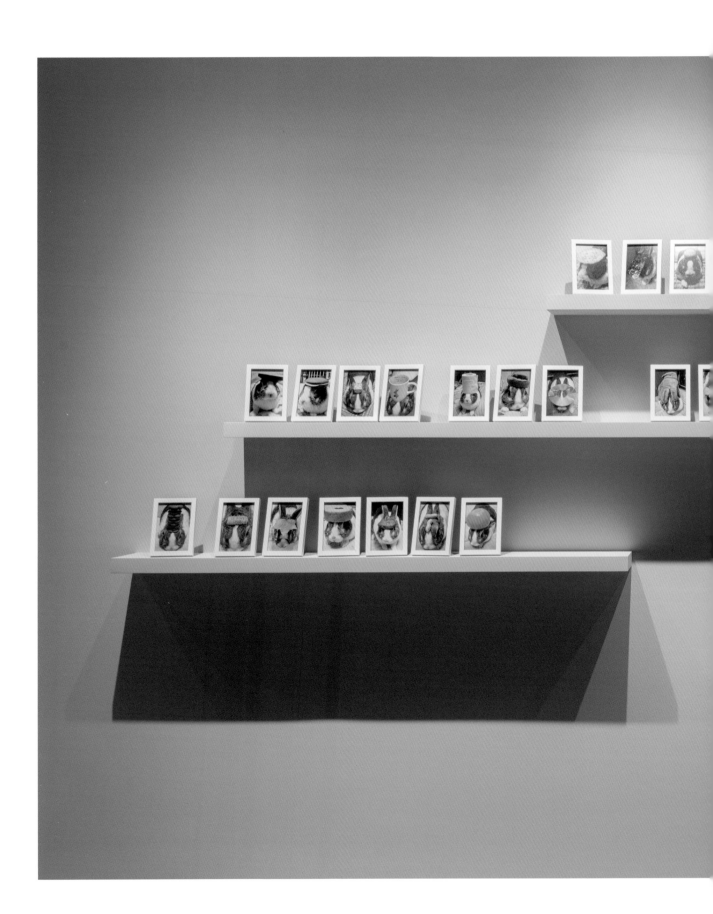

Erik Kessels, *in almost every picture #8*, 2009

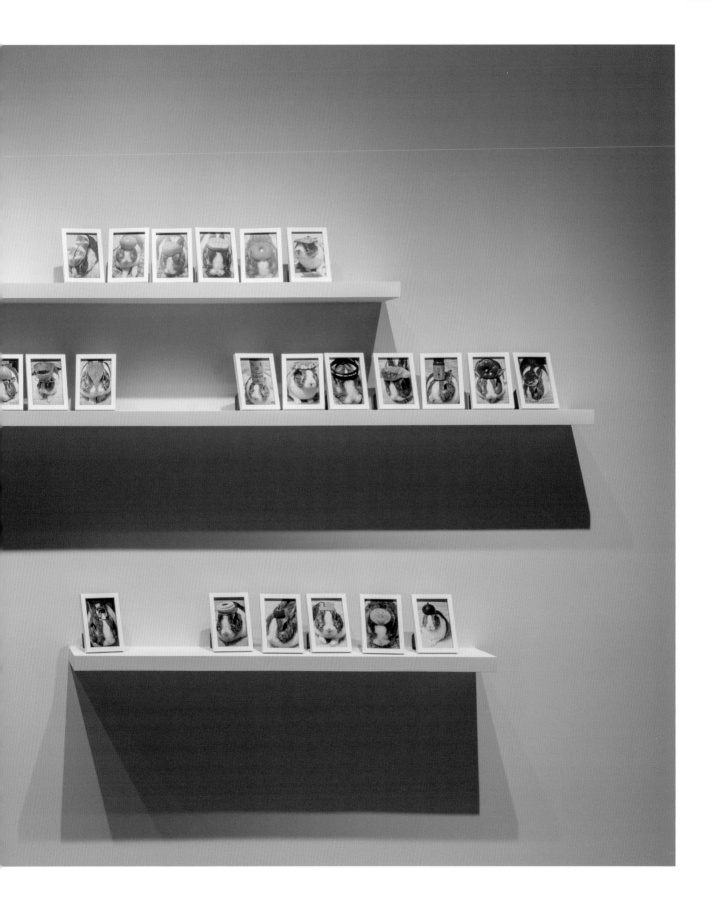

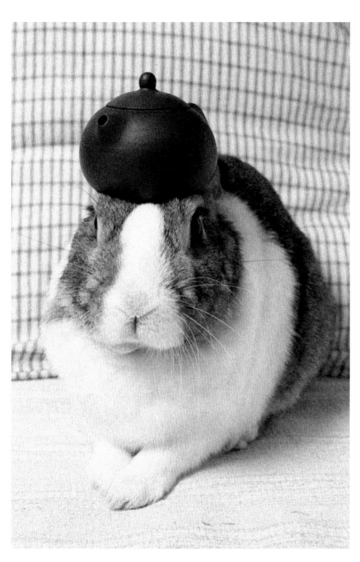 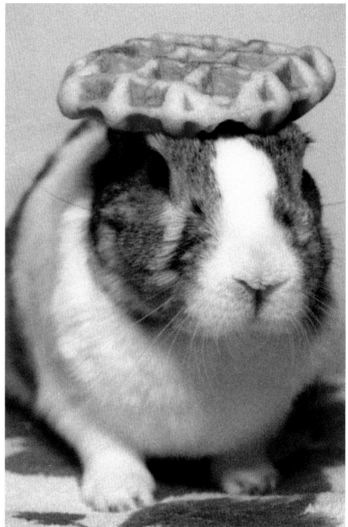

Erik Kessels, *in almost every picture #8*, 2009

These photographs depict the story of Oolong, a rabbit whose unusually flat head was ideal for balancing objects. Beginning in 1999, hundreds of images were posted on the personal blog of Oolong's owner, Hironori Akutagawa, charting the story of their unique friendship.

Erik Kessels

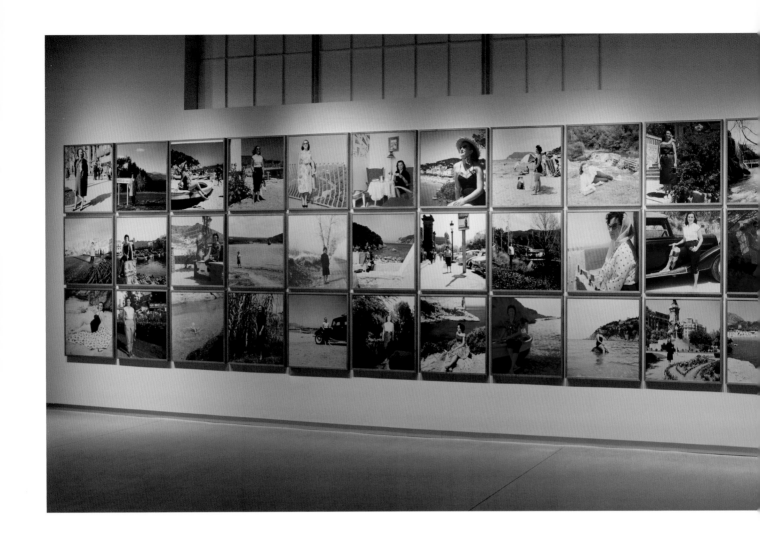

Erik Kessels, *in almost every picture #1*, 2002

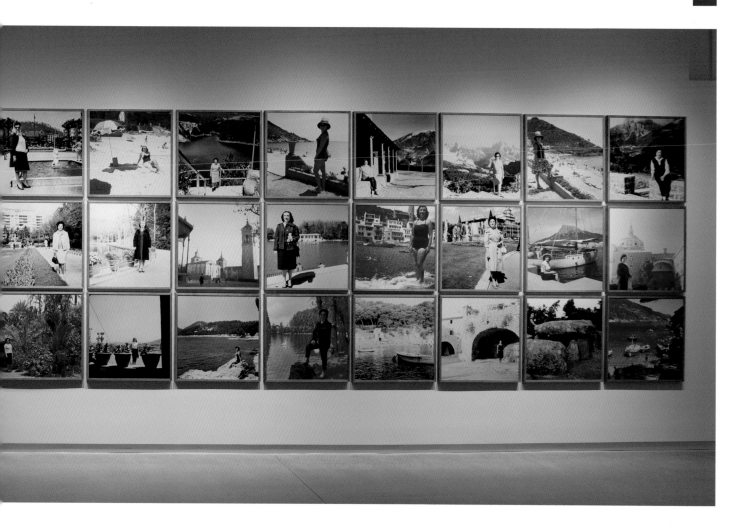

From 1956 to 1968 a husband produced hundreds of photographs of his wife while on vacations in Europe. These remarkably consistent, gracefully posed portraits, which were discovered at a public market in Barcelona, illustrate the evolution of the wife's personal style and taste. We can also see subtle changes in the photographer's technique across these photos, while given access to an ongoing series of the couple's private memories.

Erik Kessels

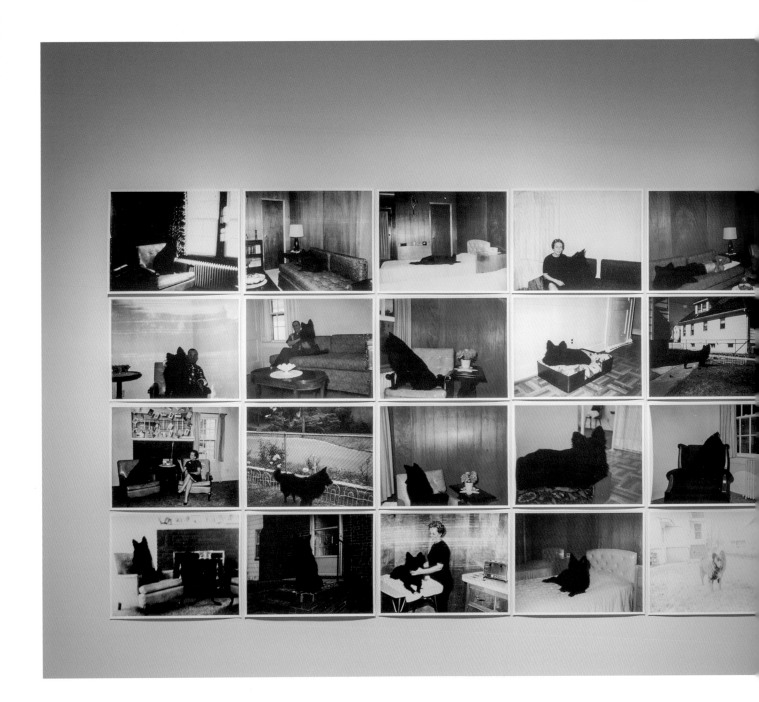

Erik Kessels, *in almost every picture #9*, 2010

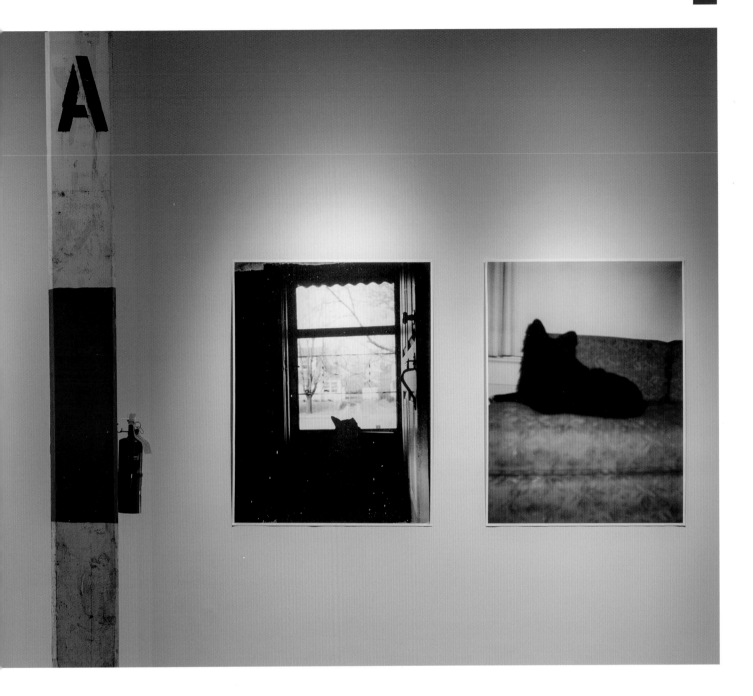

Taken between 1963 and 1965, these photographs represent a family's efforts to capture their pet dog on film. Unfortunately for the photographers, the dog has black fur, making him nearly impossible to depict clearly with their old Polaroid camera. Over and over, they tried to make accurate likenesses of their beloved pet. The resulting pictures are riddled with rather beautiful mistakes, and the volume of images gives the dog an air of mystery and importance.

Erik Kessels

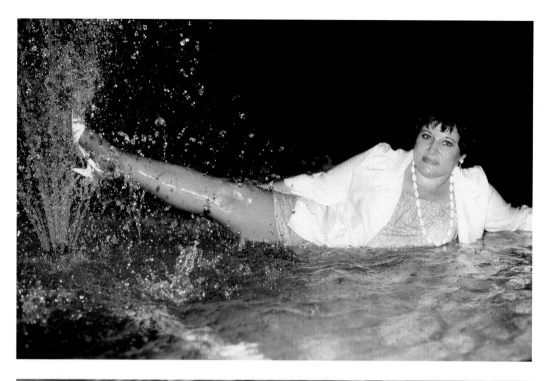

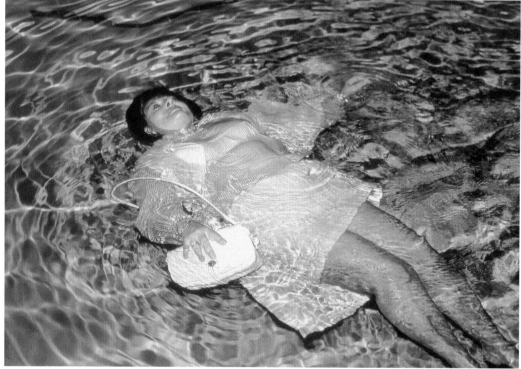

Erik Kessels, *in almost every picture #11*, 2012 (video stills)

These pictures, representing a simple but enduring game played by the photographer, Fred, and his wife, Valerie, tell the story of an obsession spanning decades. In countless images we see Valerie, impeccably dressed, with make-up, jewelry, and handbag, immersed in various bodies of water. The photographs, most of which were captured in Florida, are striking in their simplicity, both flawlessly composed and embedded with an air of spontaneity.

Erik Kessels

If I were to offer a word of caution about the endless production and distribution of images, it's that one might grow comfortably numb—that they'd lose their effect and ability to trigger outrage and mobilize change. Or, that people think they know the operation of any given image before taking the time to read it, because of some imaginary typological vault of pictures that contain finite and quantifiable data. In part, with *HORIZON/S*, I was trying in my own way to "re-mix" that.

Matt Lipps

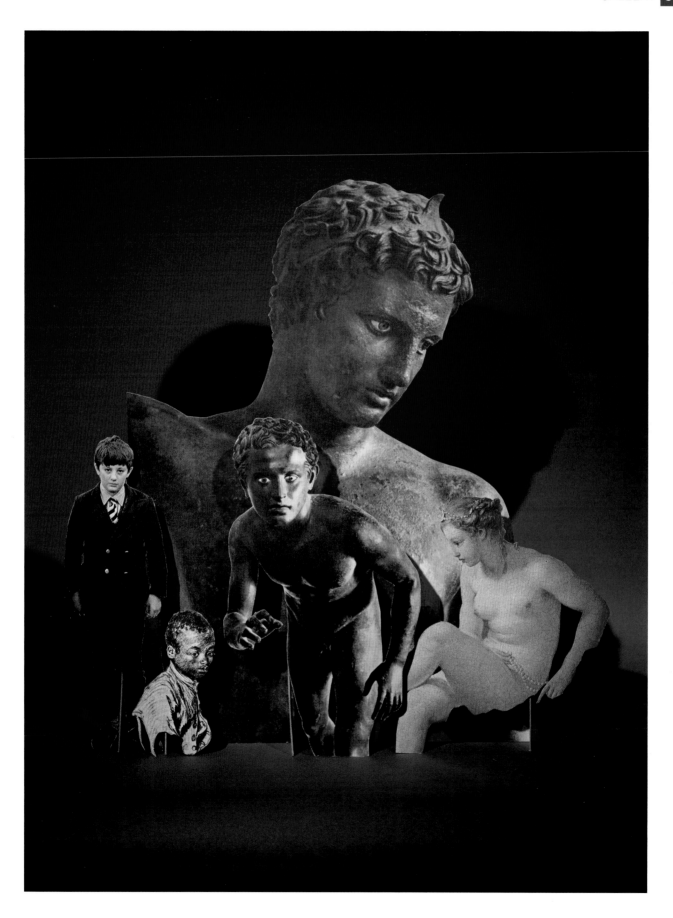

Matt Lipps, *Untitled (Youth)*, 2010

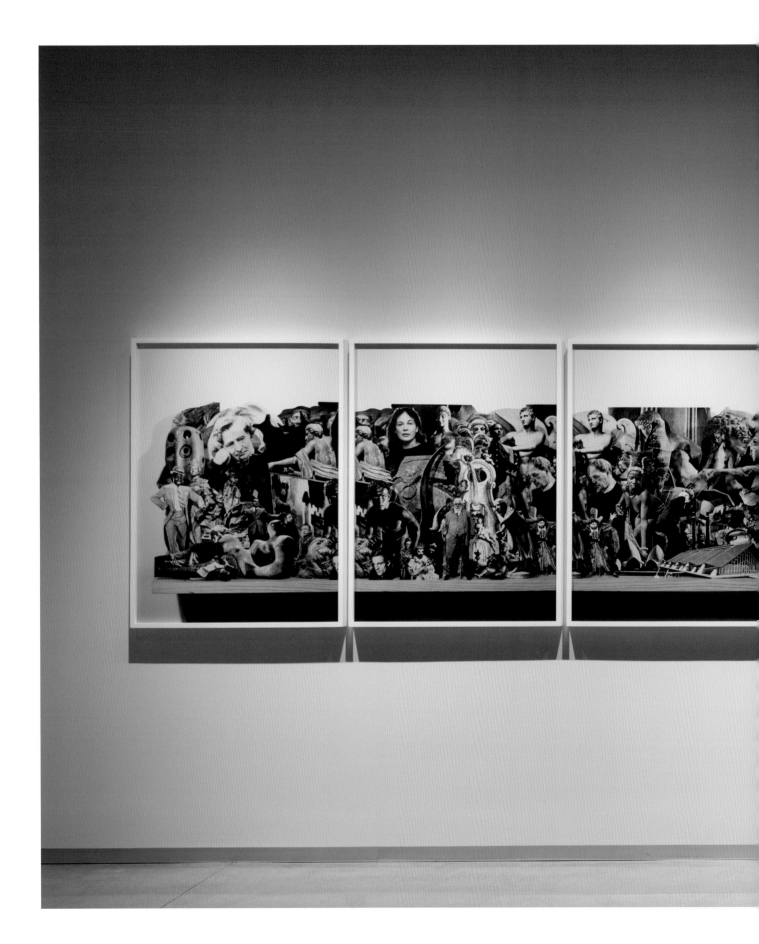

Matt Lipps, *Untitled (Archive)*, 2010

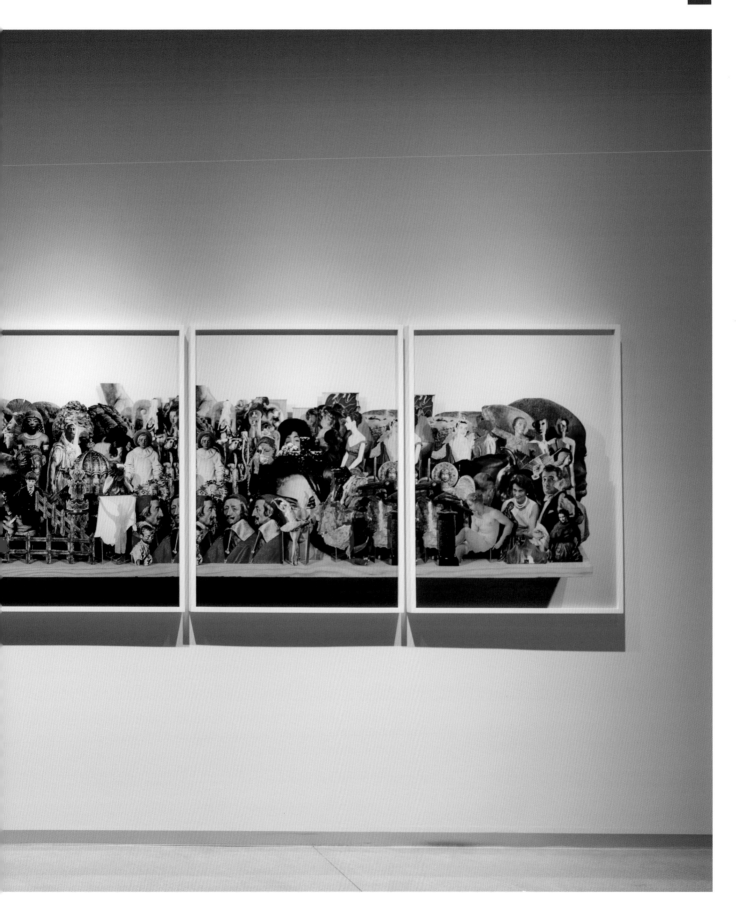

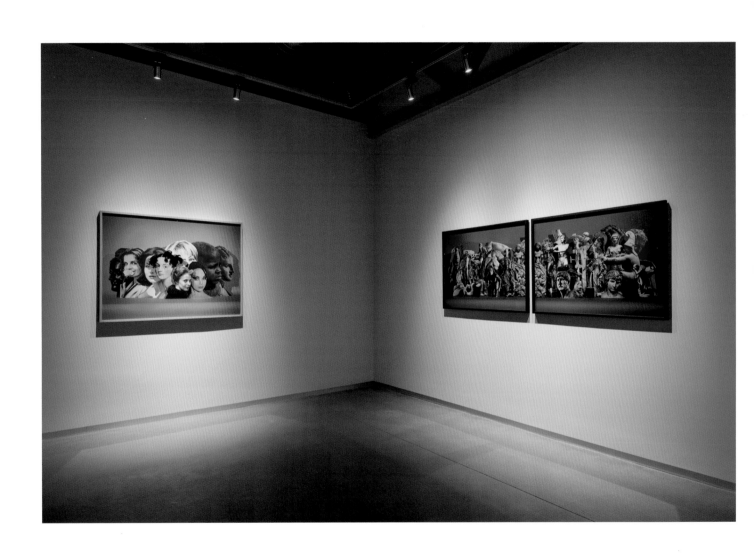

Left to right:
Matt Lipps
Untitled (Women's Heads), 2010
Untitled (Sculpture), 2010

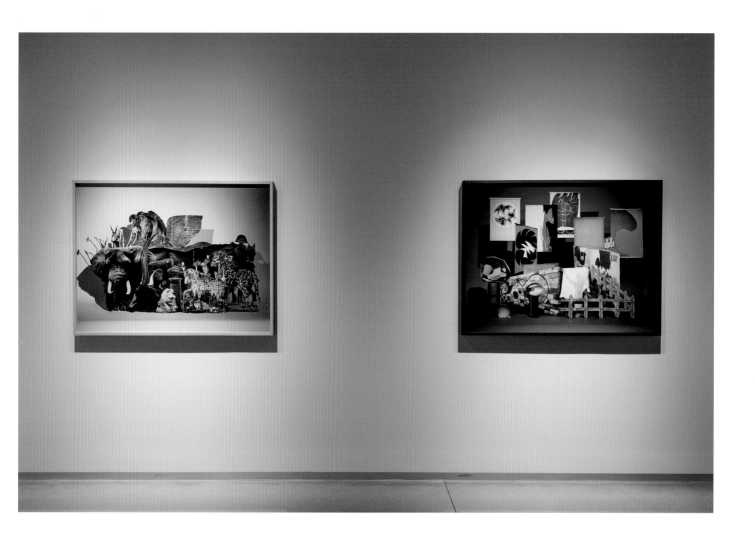

Left to right:
Matt Lipps
Untitled (Animals), 2011
Untitled (Shape), 2010

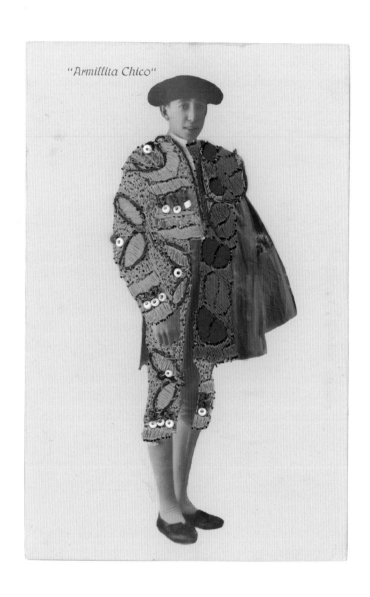

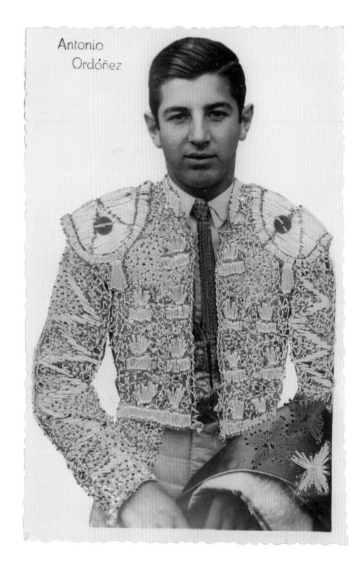

Unknown photographers, Embroidered postcards, 1910s–1940s

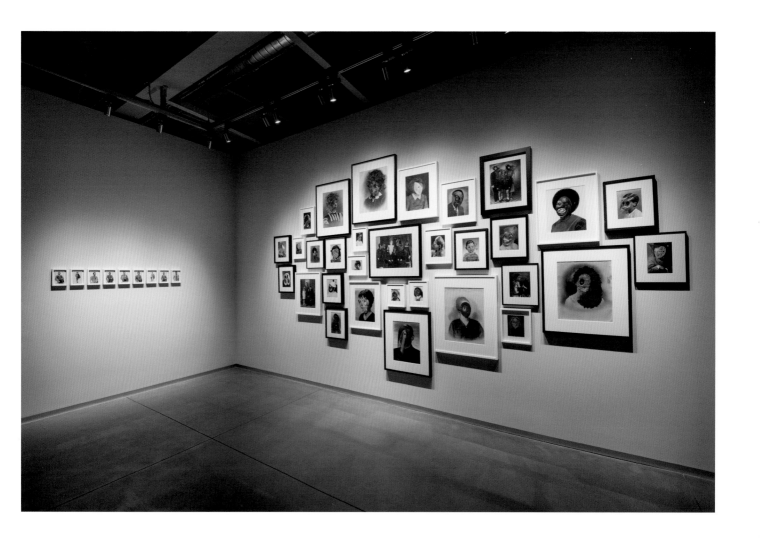

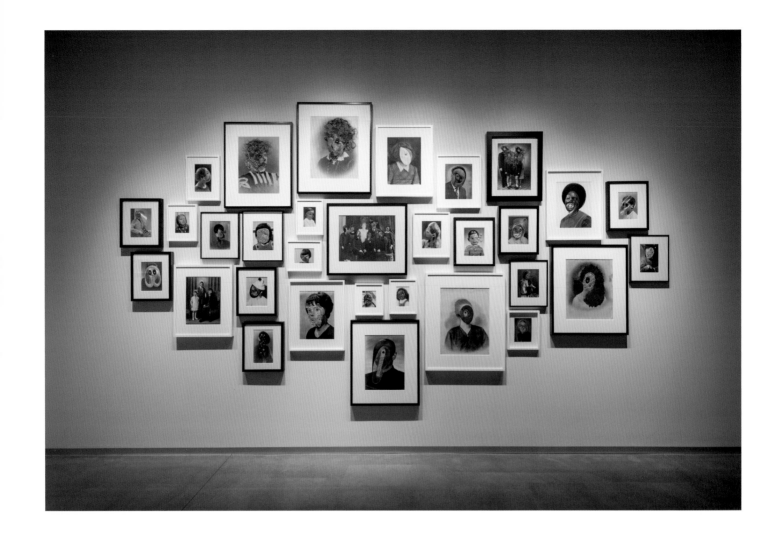

Maurizio Anzeri
01. *Mary*, 2013
02. *Theresa*, 2013
03. *Honestly*, 2013
04. *Bianca*, 2013
05. *Karl*, 2013
06. *Family 1 to 4*, 2013
07. *Steve*, 2010
08. *Jenny*, 2013
09. *Peter*, 2010
10. *Dora*, 2013
11. *Pierre*, 2013
12. *Isabella*, 2013
13. *Family*, 2011
14. *Eva*, 2012
15. *Marcel*, 2010

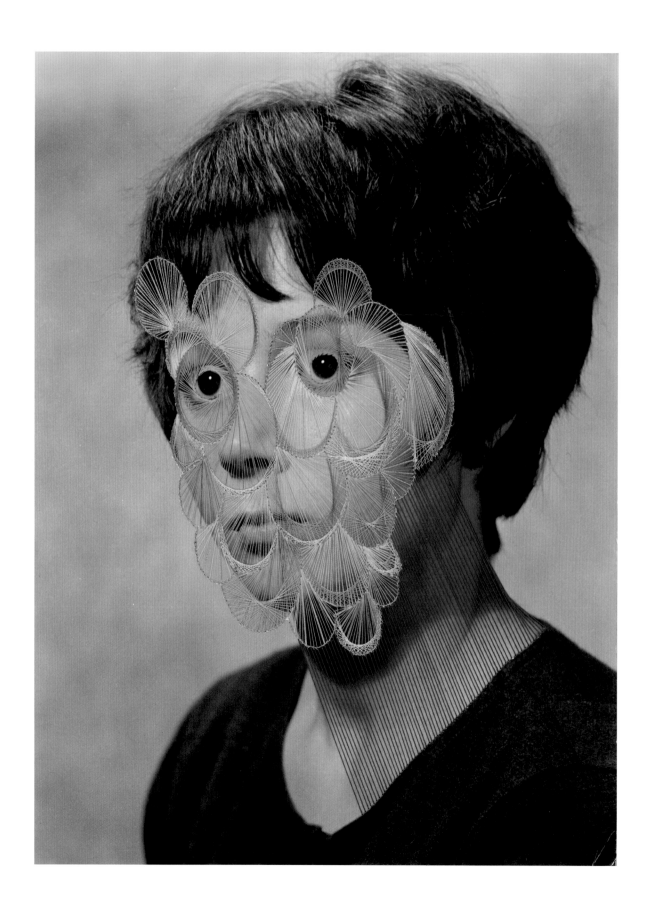

Maurizio Anzeri, *Lucia*, 2010

It's all been done before but it's never been done by you. If you don't look into the past there is no chance to go into the future.

Maurizio Anzeri

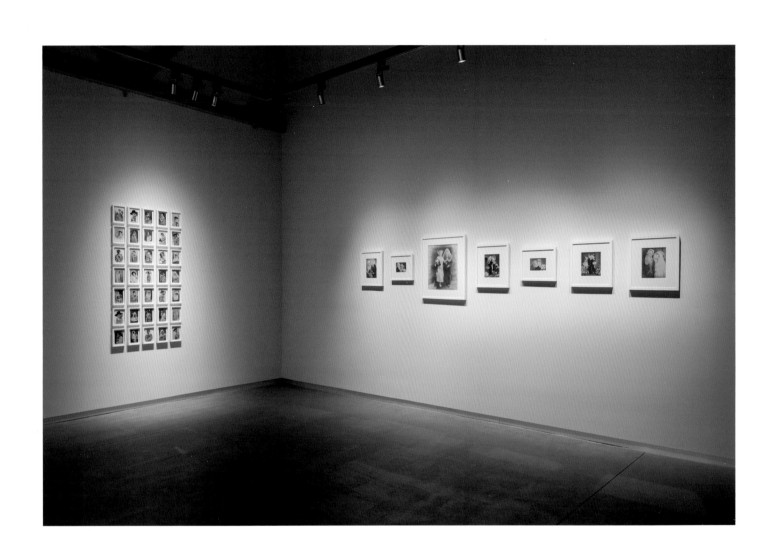

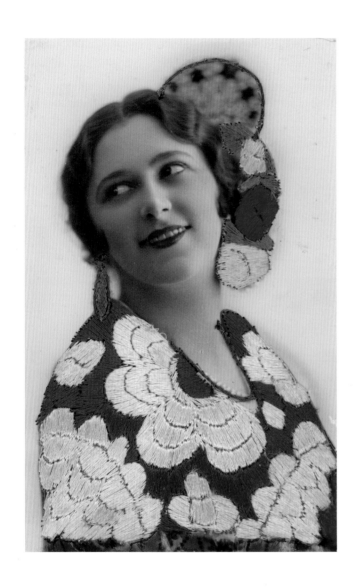

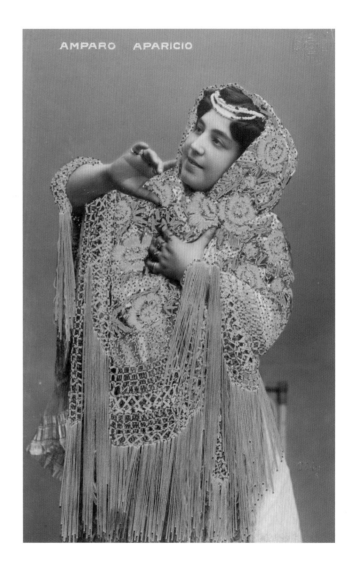

Unknown photographers, Embroidered postcards, 1910s–1940s

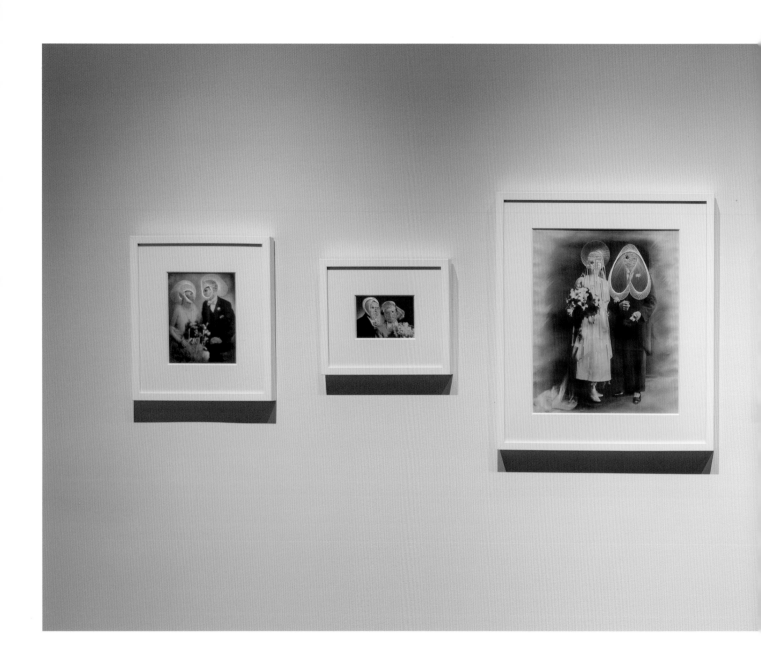

Maurizio Anzeri, selections from the series *I will be with you the night of your wedding*, 2012

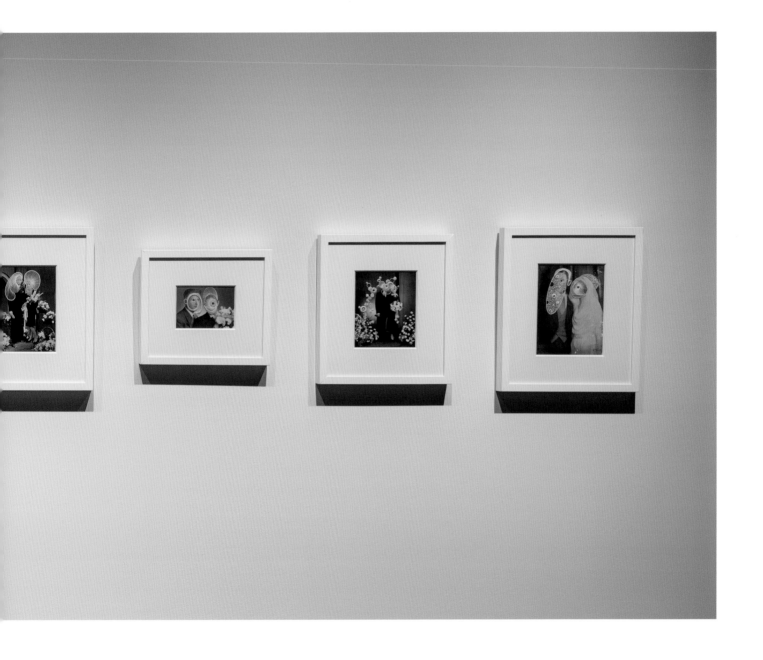

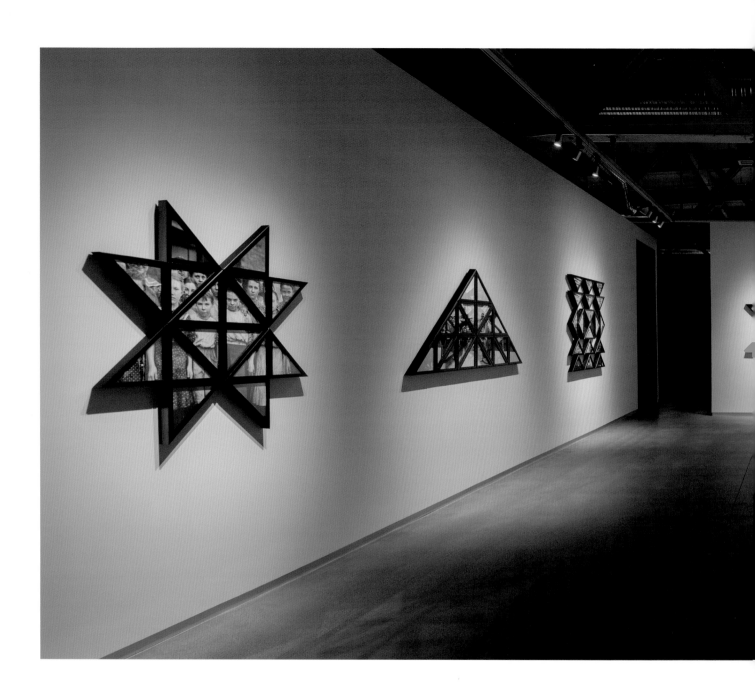

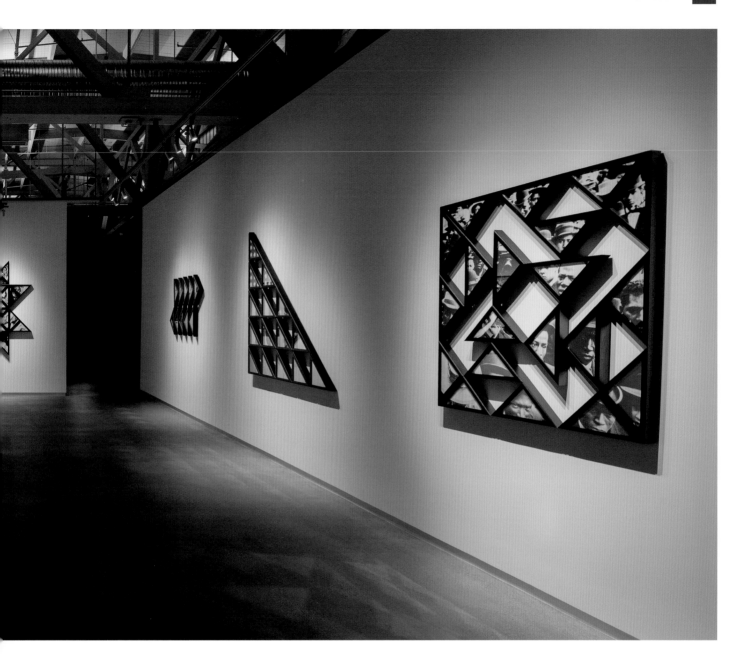

There are more images taken in a single second than we can make sense of in our entire lives. I think it's important that not just art historians but also artists themselves start to make sense of the images that we are making. I see myself, and certain artists of my generation, as the DJs of the late '70s and early '80s. We are remixing and looking, and making new imagery of existing imagery. It's beyond collage—a whole new image is created.

Hank Willis Thomas

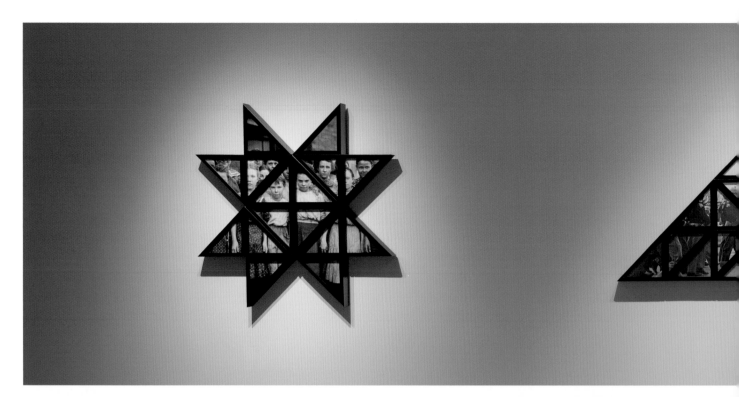

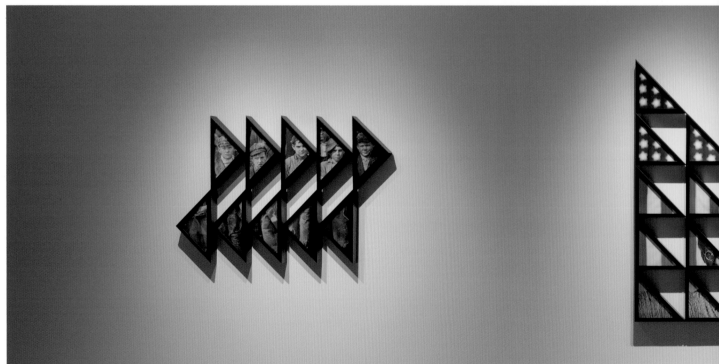

Center, previous page:
Hank Willis Thomas, *North Star*, 2013

Top, left to right:
Hank Willis Thomas
If I could tell the story in words . . ., 2013
Delta, 2014
Trouble the Water, 2013

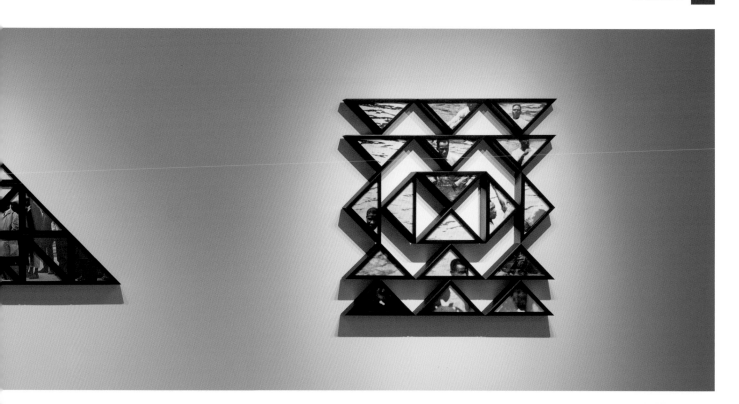

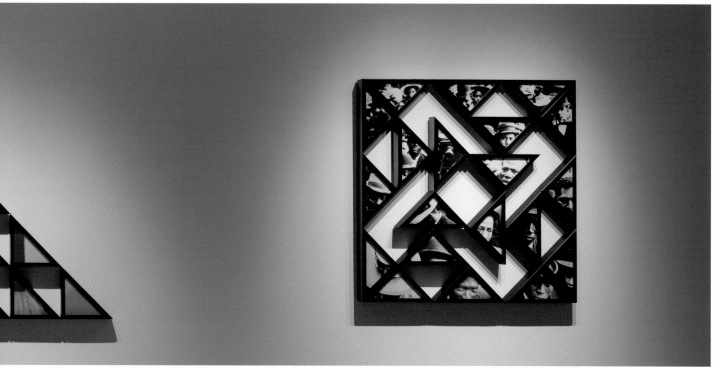

Bottom, left to right:
Hank Willis Thomas
Decagon, 2013
American Gothic, 2014
Flying Geese, 2012

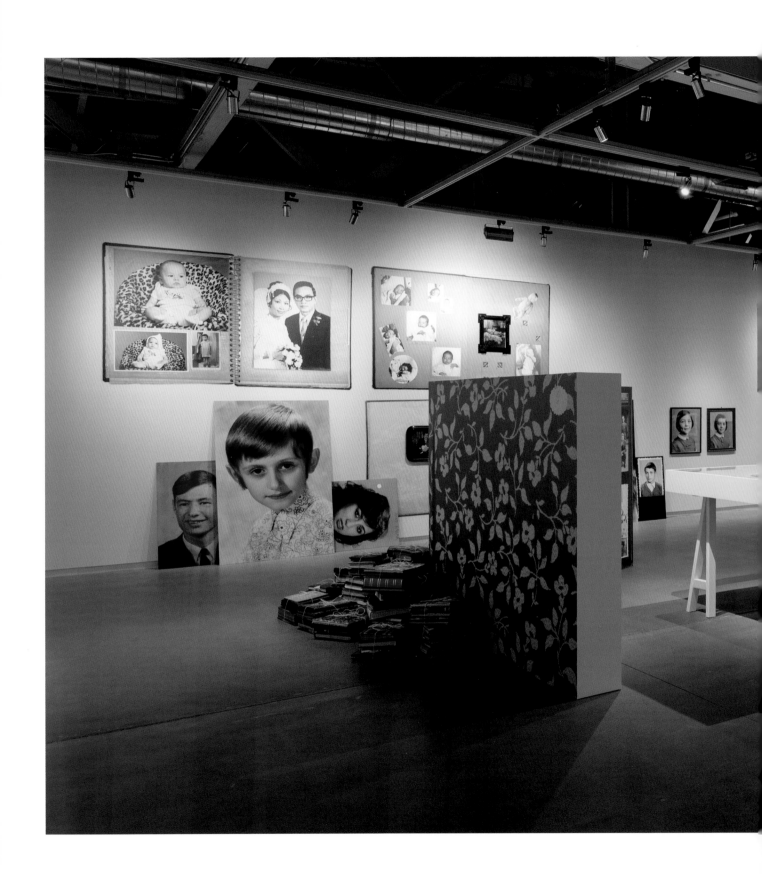

Erik Kessels, *Album Beauty*, 2012

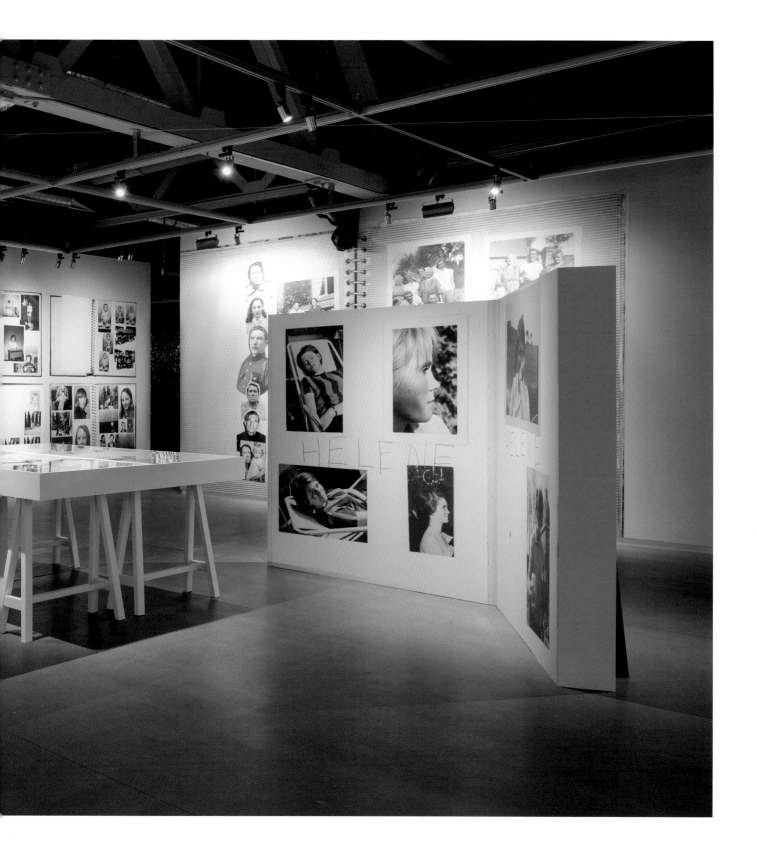

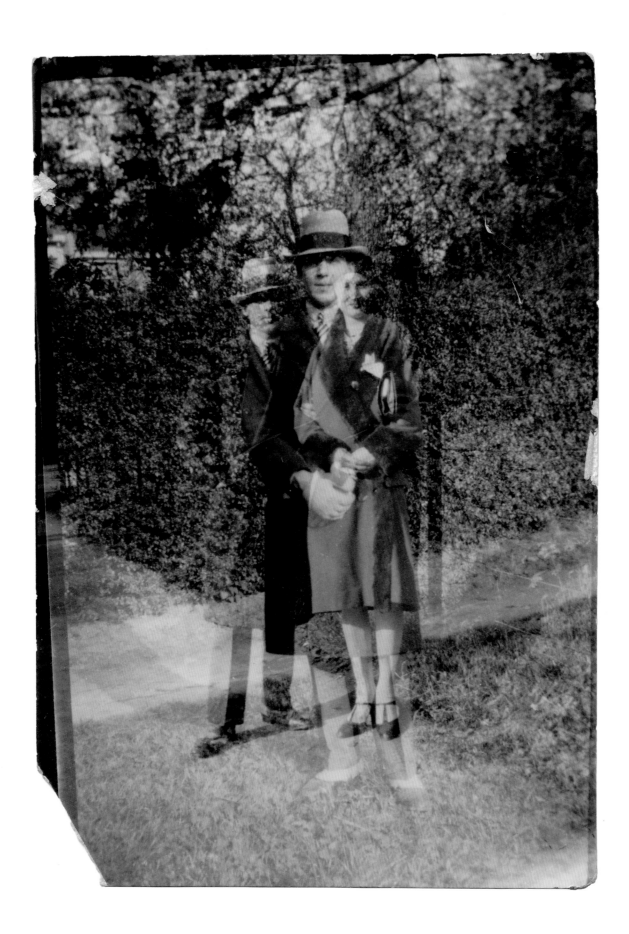

Erik Kessels, *Album Beauty*, 2012

We take snapshots to commemorate important events, to document our travels, to see how we look in pictures, to eternalize the commonplace, to extract some thread of continuity from the random fabric of experience. We try to impose a kind of order, but sometimes the process backfires, and the messy contingency of the world rushes back in, bringing with it a metaphoric richness that parallels that of dreams. The amateur photo-album is an anthology of errors: there are tilted horizons, amputated heads, looming shadows, blurs, lens flares, underexposures, overexposures, and inadvertent double exposures. And while not every bungled snapshot is a minor miracle, some seem to tap into a sort of free-floating visual intelligence that runs through the bedrock of the everyday like a vein of gold.

Mia Fineman

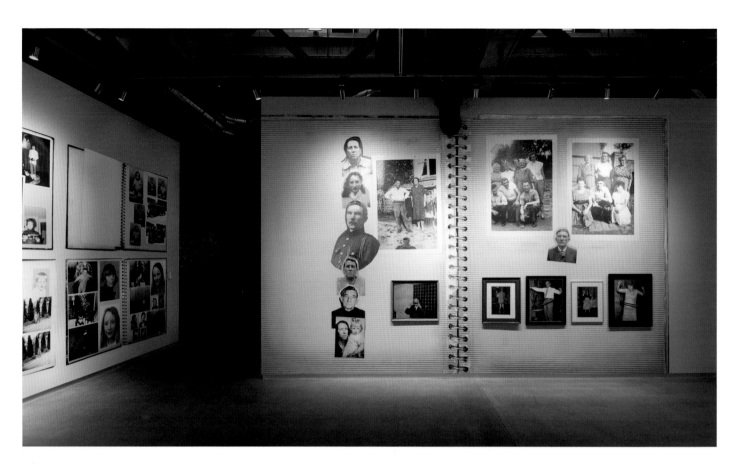

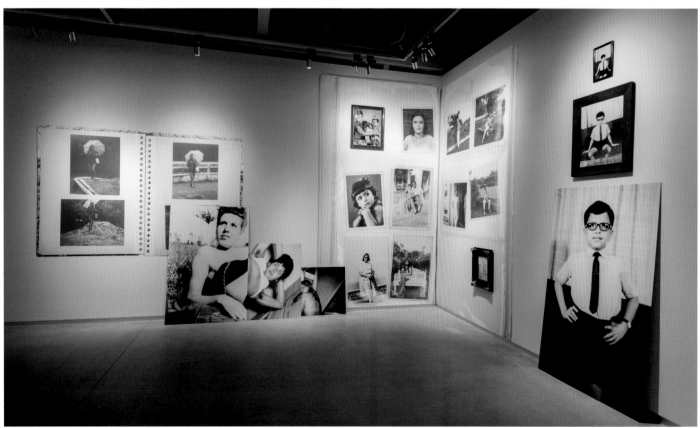

Erik Kessels, *Album Beauty*, 2012

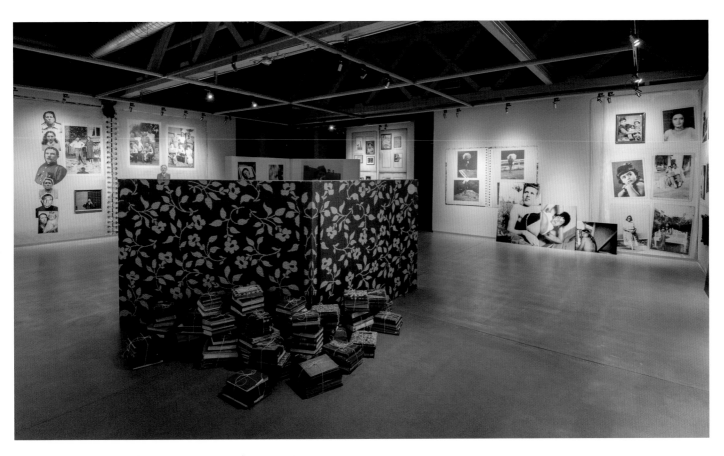

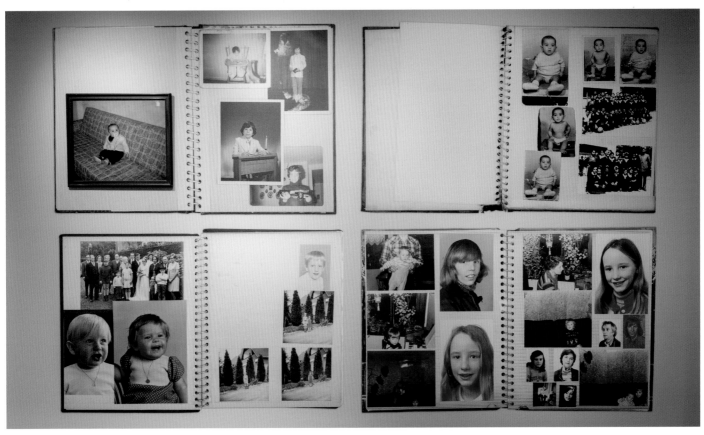

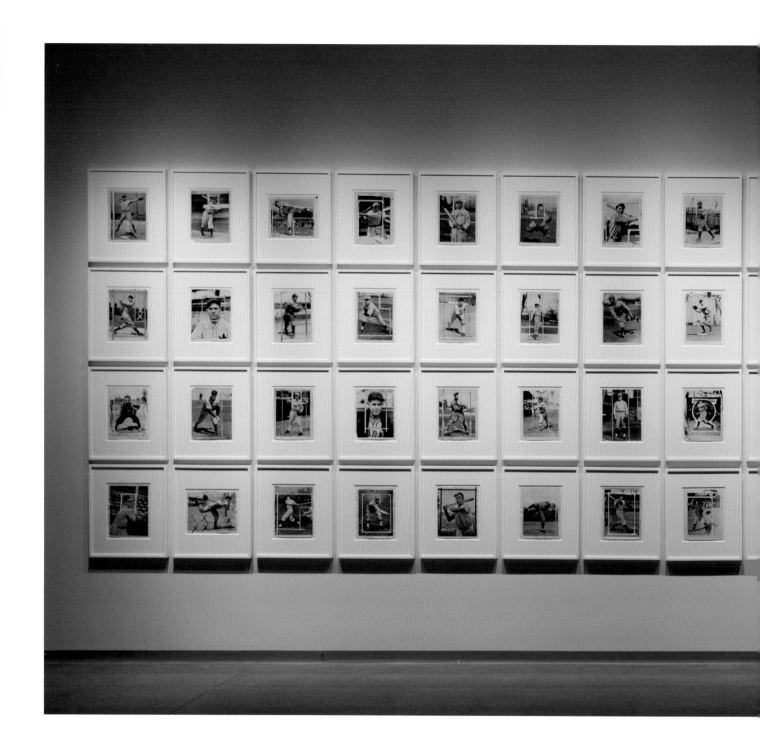

Unknown photographers, Press photos: baseball, 1930s–1940s

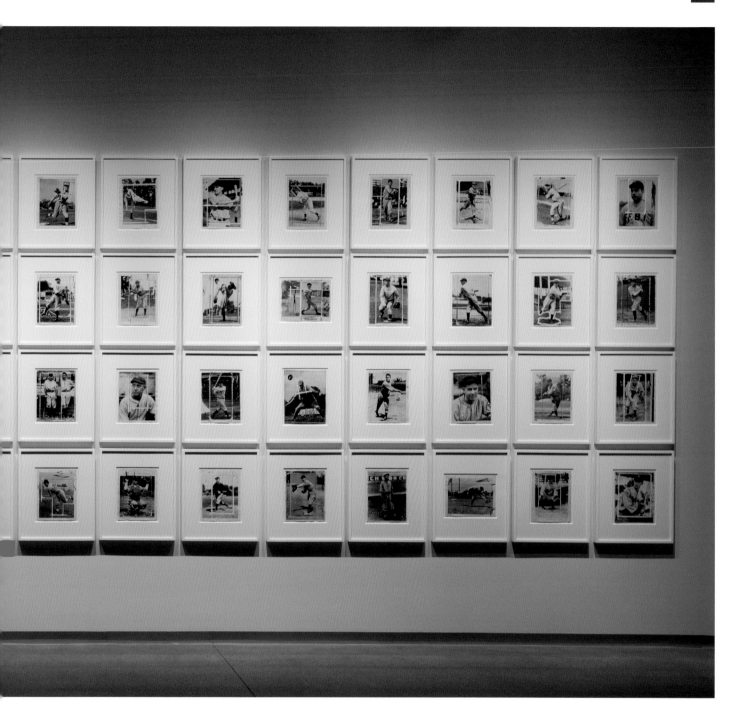

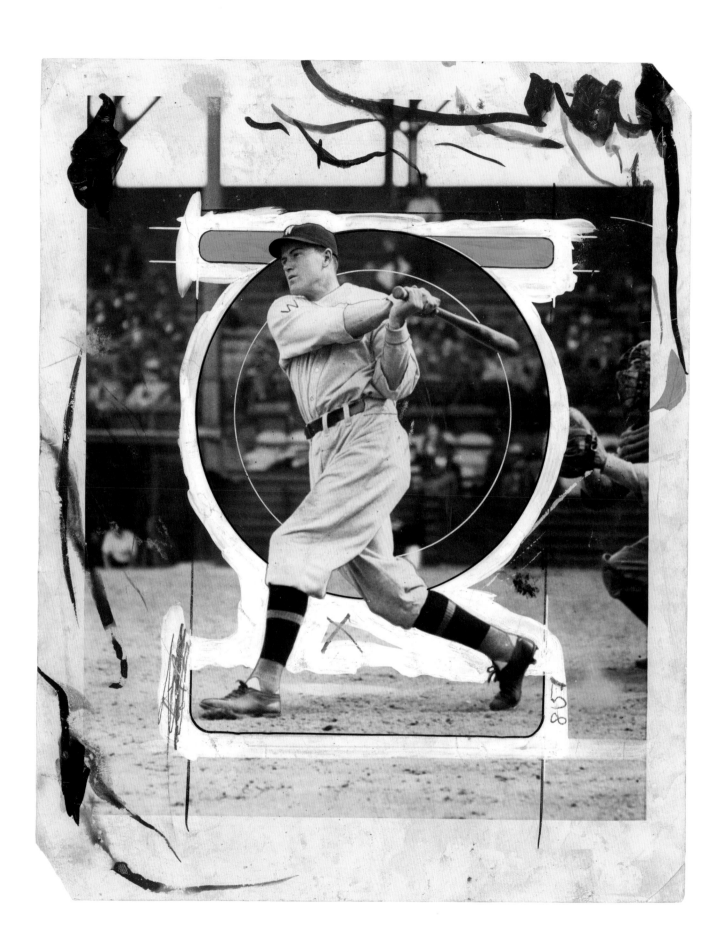

Unknown photographer, Press photo: baseball, 1930s–1940s

The halftone process, invented in the 1880s and perfected over the next two decades, made it possible to mechanically reproduce a photograph in ink by translating the image into a grid of tiny black dots of varying sizes, which, depending on their density, created gradations from white through all shades of gray to deepest black.

Stephen H. Horgan, one of the inventors of the halftone process, observed in 1884, "very rarely will a subject be photographed with the composition, arrangement, and light and shade of a quality possessing sufficient 'spirit' for publication in facsimile. All photographs are altered to a greater or lesser degree before presentation in the newspaper." More often than not, these alterations were cosmetic or corrective: highlights were brightened and shadows darkened to increase contrast; important subjects were outlined for emphasis; distracting background elements were blurred; extraneous figures were cropped or painted out.

Mia Fineman

Left to right:
Daniel Gordon
Avocado, 2013
Lemons, 2013
Oranges, 2013
Banana, 2013
Onions, 2013
Watermelon, 2013
Asparagus, 2013
Apple, 2013
Artichoke, 2013
Limes, 2013
Pear, 2013
Ratatouille and Smoke Bush, 2014
Lilies and Clementines, 2011

Left to right:
Daniel Gordon
Still Life with Lobster, 2012
Pink Ladies and Pears, 2012

I found that once I began appropriating images, whole worlds of possibility opened up to me, and I was able to create a more exciting way of working that involved a kind of improvisation. I make life-size, three-dimensional objects and photograph them with a 4×5 or 8x10 inch large-format camera. I do this because in life, the objects I make are just junk—they only become emotionally convincing through photography's transformation.

Daniel Gordon

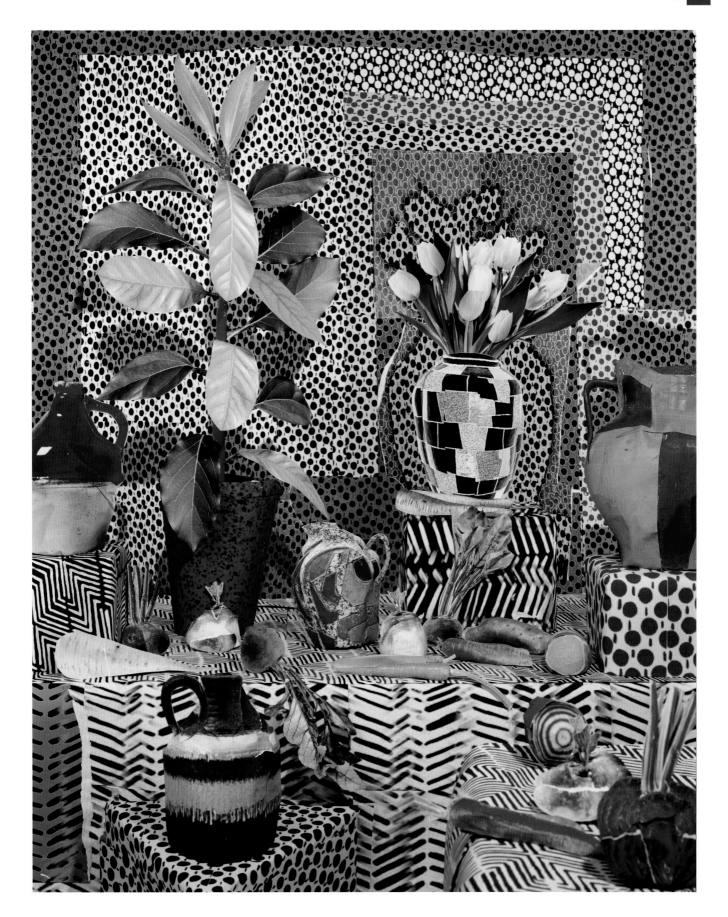

Daniel Gordon, *Root Vegetables and Avocado Plant*, 2014

Organic growth has characterized the formation of the Archive of Modern Conflict, which came into being some twenty years ago and has expanded and developed as its themes and topics have interacted to create new areas of collecting.

One of the Archive's original aims was to collect and analyze historic photography in order to understand the nature and causes of strife in the world. The answer to this compelling question is no clearer now than it was at the beginning, but in the process a mass of evidence has been assembled. As the material was acquired it became clear that we couldn't restrict ourselves to conflict pure and simple. All kinds of subject matter appeared relevant, and we felt able to neglect none of it. This realization has been the principal motor of the collection's growth.

The photographs in the Archive now span a wide range of genres and locations. There are images from just about everywhere, and examining the planet as a whole has emerged as one of many threads running through the works. Indeed, the Archive holds imagery from all walks of life, micro and macro, tribal and metropolitan, imperial and postimperial, from the distant 1840s right up to the present moment.

Every time we see a photograph we know that time has been stopped. Shadows old and new, frozen by the click of a shutter button, now circulate in the billions. *Collected Shadows* presents just a few of the multitude of shadows that populate the Archive's collection—small moments that have been shuffled and rearranged to recount yet another of photography's inexhaustible variants.

The Archive of Modern Conflict

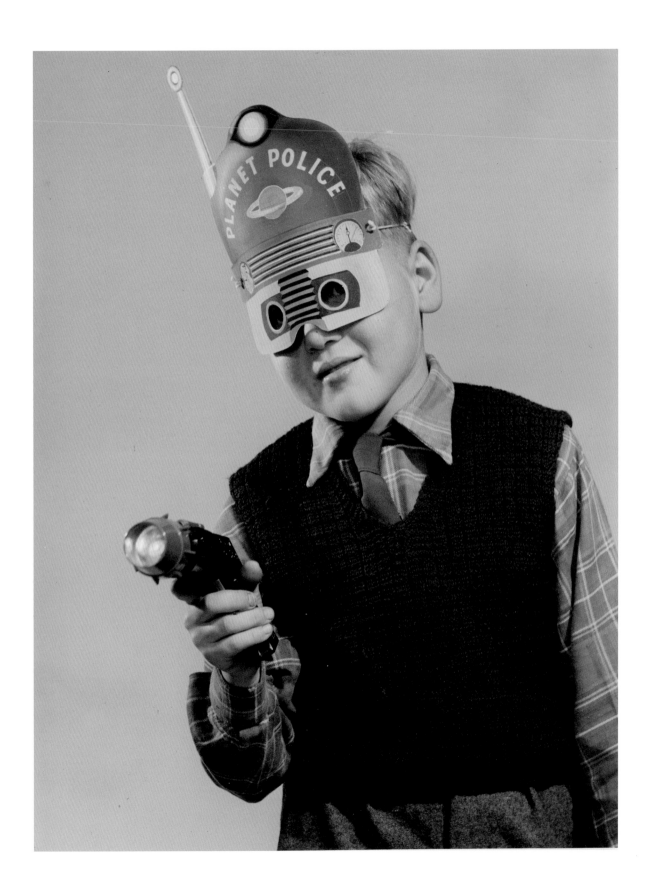

Studio of Bert Hardy, *Planet Police*, ca. 1950

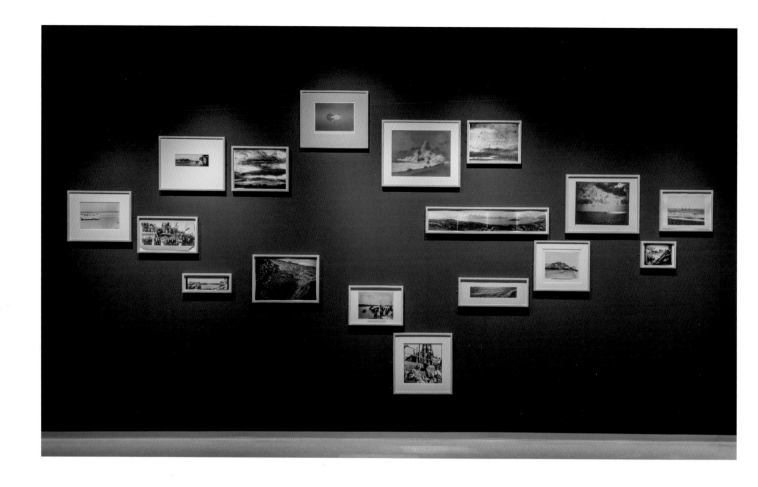

Archive of Modern Conflict, *Collected Shadows*, 2012

01. **Robert Frank**, *Daytona Beach, Florida*, 1962

02. **Unknown photographer**, *Yugoslav immigrants arriving on a steamer at Santos, Brazil*, ca. 1920

03. **Unknown photographer**, *Port Said*, 1907

04. **Unknown photographer**, *Pilchard Fishery, Cornwall*, ca. 1890

05. **Mario Giacomelli**, *Migrating birds in flight*, ca. 1980

06. **Boris Smelov**, *Flood on the Palace Embankment, Leningrad*, 1978

07. **T.T. Paterson**, *James Wordie Arctic Expedition*, 1935–36

08. **John Thomson**, *Canton River*, 1870

09. **Unknown photographer**, *Stormy sea on the coast of Ceylon (Sri Lanka)*, ca. 1900

10. **Daniel Farson**, *Blackpool*, ca. 1951

11. **Axel Lindahl**, *Nordland, panorama of Skjoldvær, Lofoten*, ca. 1895

12 **Mario Giacomelli**, *Migrating birds in flight*, ca. 1980

13. **Gustave Le Gray**, *Mediterranean sea, Sète (an extract from the much larger picture of the coast at Sète)*, 1857

14. **Joseph Vigier**, *Hastings*, 1852

15. **Gustave Le Gray**, *The Brig, Normandy*, 1856

16. **James Valentine**, *Harbour Scene*, 1856

17. **Unknown photographer**, *Sunken three-mast ship*, ca. 1870

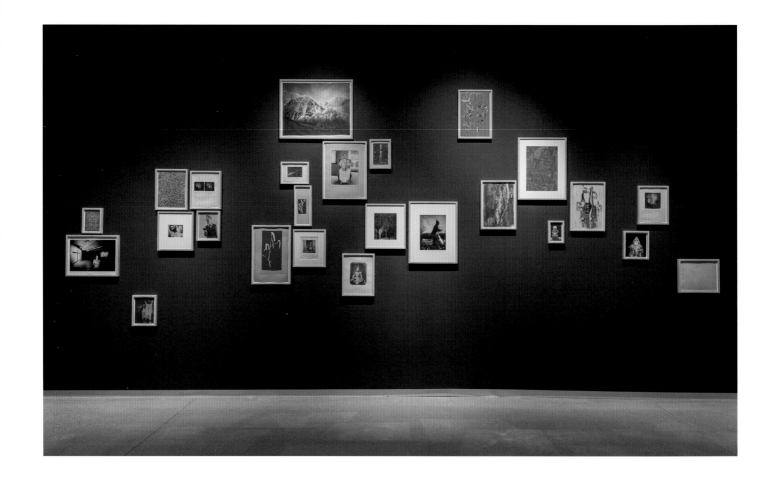

Archive of Modern Conflict, *Collected Shadows*, 2012

01. **Johann Böhm**, *Iron filings under the influence of electricity*, ca. 1925

02. **Digne Meller Marcovicz**, *Blinky Palermo in an underpass in Munich*, ca.1965

03. **Unknown photographer**, *Butchers*, ca. 1900

04. **Aleksandr Khlebnikov**, *Lentils*, ca. 1930

05. **Attributed to Nikolai Suetin**, *Kasimir Malevich, last moments*, 1935

06. **Frederik Carl Störmer** (left) **and Carsten Borchgrevink** (right), *Aurora borealis from Bygdø and Tømse*, ca. 1926

07. **Studio of Bert Hardy**, *Planet Police*, ca. 1950

08. **Bertha Jaques**, *Plant study*, ca. 1910

09. **John Claude White**, *Samiti Lake from Goecha La, Sikkim, Calcutta, ateliers Johnston & Hoffmann*, 1905

10. **Ferdinand Quénisset**, *Photograph of the Morehouse Comet*, 1908

11. **Bertha Jaques**, *Willow Catkins*, 1909

12. **Hans Casparius**, *Sigmund Freud*, 1933

13. **Unknown photographer**, *Indian man*, 1950

14. **Philippe Jacques Potteau**, *Member of Siamese diplomatic mission to Paris*, 1865

15. **Ferdinand Quénisset**, *Photograph of the Morehouse Comet*, 1908

16. **Brassaï**, *Les Plantanes de Quai Bercy*, 1946

17. **Sergei Yutkevich**, *Man with an umbrella*, 1974

18. **Jaroslav Rössler**, *Composition with colour gels*, ca. 1970

19. **Jaroslav Rössler**, *Composition with colour gels*, ca. 1970

20. **Jaroslav Rössler**, *Composition with colour gels*, ca. 1970

21. **Unknown photographer**, *Shi'ite cleric, Iran*, 1895

22. **Jaroslav Rössler**, *Composition with colour gels*, ca. 1970

23. **Unknown photographer**, *circle of Dimitri Ivanovich Ermakov, Armenian patriarch*, ca.1890

24. **Frederik Carl Störmer**, *Aurora borealis from Bygdø, near Oslo*, 1926

25. **Aleksandr Khlebnikov**, *Plaster wall*, ca. 1930

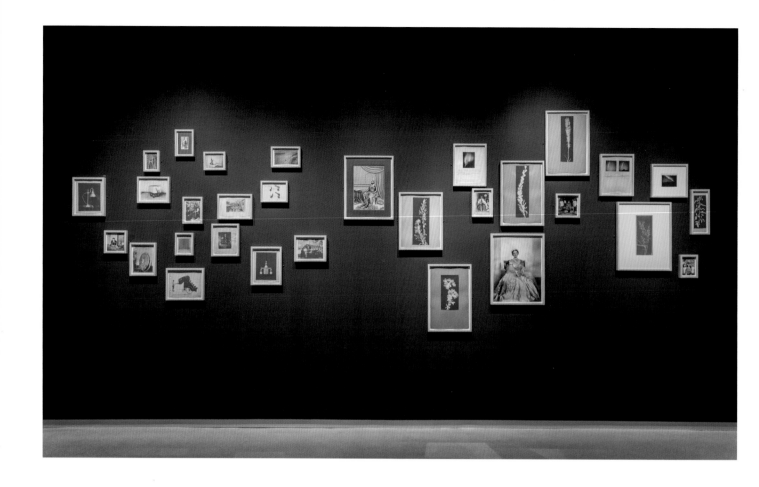

Archive of Modern Conflict, *Collected Shadows*, 2012

01. **Unknown photographer**, *Portable lamp*, 1910s

02. **Unknown photographer**, *Science student*, ca. 1900

03. **Unknown photographer**, *Industrial Machine Part*, 1910

04. **Unknown photographer**, *Hendy Matterson mini cart*, 1910

05. **Johann Böhm**, *Iron filings under the influence of electricity*, 1925

06. **Unknown photographer**, *Man with a camera*, ca. 1910

07. **Unknown photographer**, *Fertiliser loader*, 1910

08. **René Barthélemy**, *A belinograph image*, 1930

09. **Unknown photographer**, *Photographer's family portrait*, ca. 1890

10. **Unknown photographer**, *Electrical apparatus*, ca. 1900

11. **Unknown photographer**, *E. Long's Solar printing works, Quincy, IL*, 1886

12. **F. E. Walker**, *Switchboard at Thorton Bros. opera house, Riverpoint, R.I.*, 1895

13. **Unknown photographer**, *R548 combination light*, ca. 1900

14. **Unknown photographer**, *Roller skates, the Richard Manufacturing Company, Bloomsburg, PA*, ca. 1910

15. **Charles Henry Turner**, *Sand dunes*, 1910

16. **Unknown photographer**, *Industrial Machine*, 1920s

17. **Unknown photographer**, *Indian prince*, 1880

18. **Bertha Jaques**, *Plant study*, 1910

19. **Bertha Jaques**, *Plant study*, 1910

20. **Frederik Carl Störmer**, *Aurora borealis taken from Bygdø, near Oslo*, 1926

21. **Francis W. Joaque**, *West African King*, 1870

22. **Dorothy Wilding**, *Queen Elizabeth the Queen Mother*, 1954

23. **Bertha Jaques**, *Blazing Star*, 1909

24. **Bertha Jaques**, *Plant study*, 1910

25. **Francis W. Joaque**, *West African King*, 1870

26. **Frederik Carl Störmer**, *Aurora borealis from Os carsborg and Bygdø, near Kristiania*, 1919

27. **Bertha Jaques**, *Plant study*, 1910

28. **Frederik Carol Störmer**, *Aurora borealis with landscape*, 1920

29. **Francis W. Joaque**, *West African King*, 1870

30. **Bertha Jaques**, *Plant study*, 1910

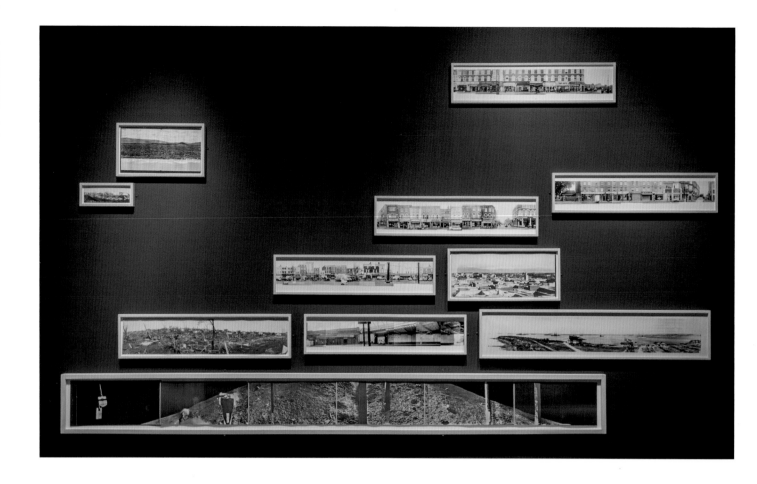

Archive of Modern Conflict, *Collected Shadows*, 2012

01. **Unknown photographer**, *Calles Shell Magazine at Agua Prieta*, 1915

02. **Unknown photographer**, *WW2, US, aviation*, 1940s

03. **Soviet Space Agency**, *Panorama of the moon's surface*, 1966

04. **Hindmarsh**, *Panorama of the Seward Tornado, Nebraska*, 1913

05. **Antony Cairns**, *Panorama of Kingsland Road, Dalston, London*, 2011

06. **Antony Cairns**, *Panorama of Kingsland Road, Dalston, London*, 2011

07. **Antony Cairns**, *Panorama of Kingsland Road, Dalston, London*, 2011

08. **Antony Cairns**, *Panorama of Kingsland Road, Dalston, London*, 2011

09. **Unknown photographer**, *Panorama of Marrakech, Morocco*, 1920s

10. **Unknown photographer**, *Panorama of Guantanamo Bay*, 1920s

11. **Anthony Cairns**, *Panorama of Kingsland Road, Dalston, London*, 2011

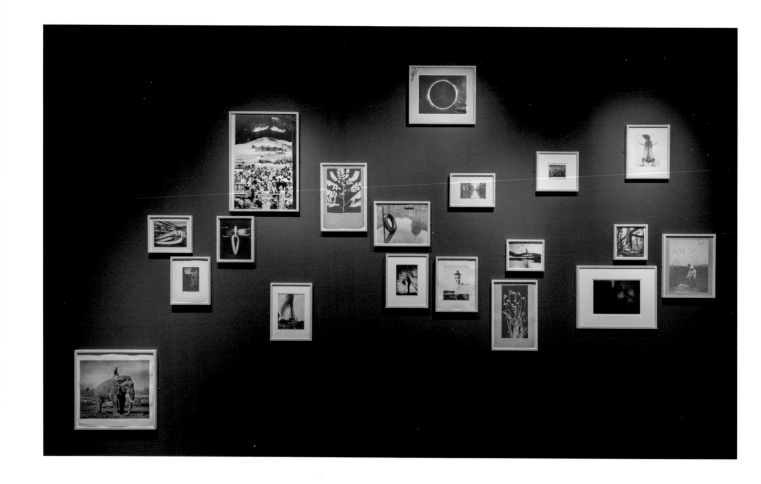

Archive of Modern Conflict, *Collected Shadows*, 2012

01. **Unknown photographer**, *Sir Jung Bahadur's fighting elephant*, ca. 1860

02. **Guillermo Kahlo**, *Cabinetto de Zoologia, Mexico City*, 1902

03. **Ema Spencer**, *On the longed-for hobby-horse*, 1902

04. **Unknown photographer**, *South African diamond mining poster*, ca. 1960

05. **Jaroslav Rössler**, *Abstract composition*, 1927

06. **Dimitri Ivanovich Ermakov**, *Baku, oil well*, ca. 1895

07. **Bertha Jaques**, *Plant Study*, ca. 1910

08. **Unknown photographer**, *Solar eclipse, Astronomer Royal's expedition, Giggleswick, New Yorkshire*, 1927

09. **Vilem Reichmann**, *In our courtyard, from the Couples cycle*, 1963

10. **Unknown photographer**, *Parachutist*, 1940s

11. **Henri Joseph Sauvaire,** *Hebron: view of a minaret*, 1866

12. **Unknown photographer**, *1st Street flooded looking north down Taylor, Boston*, 1880s

13. **Ferdinand Quénisset**, *Scientific photograph: Study of ice crystals*, 1908

14. **Bertha Jaques**, *Plant study: In the grass*, 1910

15. **Jaroslav Rössler**, *Abstract Composition*, 1960s

16. **Thomas Joshua Cooper**, *Ceremonial Dwelling, Nesscliffe, England*, 1975

17. **Unknown photographer**, *London bomb damage*, 1940s

18. **Unknown photographer**, *Locusts in Morocco*, 1896

19. **Unknown photographer**, *X-ray of a rat*, ca.1910

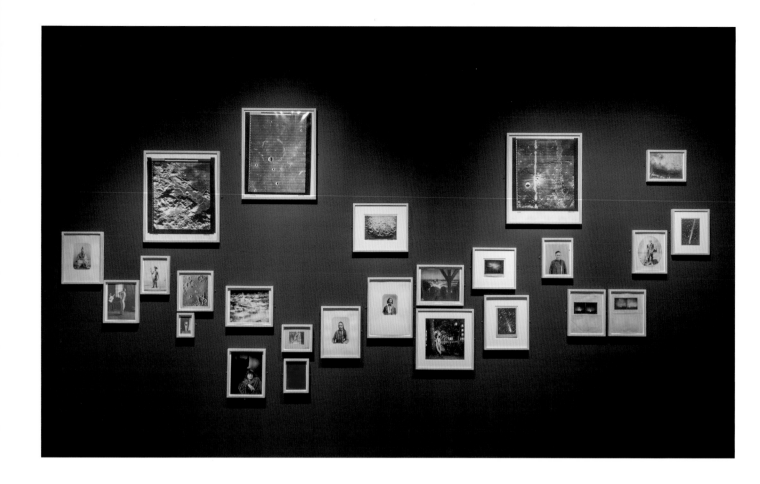

Archive of Modern Conflict, *Collected Shadows*, 2012

01. **Philippe Jacques Potteau**, *Ta-naka, 1st class officer and 2nd secretary in the Japanese embassy in Paris*, 1859

02. **Paul Burty Haviland**, *Flamenco dancer*, 1909

03. **Marc Ferrez**, *Costume des chefs indiens*, 1870s

04. **NASA**, *Satellite image of lunar surface*, ca. 1970

05. **Unknown photographer**, *The dimensions of Paris displaced onto the surface of the moon*, ca. 1895

06. **Unknown photographer**, *Gymnast*, ca. 1890

07. **NASA**, *Satellite photo of lunar surface*, ca. 1970

08. **Universum Film AG (UFA) and Fritz Lang**, *Die Frau im Mond* (The woman in the moon), 1929

09. **Count Theodore Zichy**, *Benny Hill*, ca. 1957

10. **J.N. Krieger**, *Surface of the moon*, 1893

11. **Unknown photographer**, *Image from John Logie Baird's first television demonstration*, 1926

12. **Philippe Jaques Potteau**, *Yelloub Ben Gobji, soldier of the 1st class in the 2nd Tirailleurs Algériens*, 1865

13. **Unknown photographer**, *Surface of the moon*, ca. 1895

14. **Paul-Émile Miot**, *Mi'kmaq man, Newfoundland*, ca. 1859

15. **Universum Film AG (UFA) and Fritz Lang**, *Die Frau im Mond* (The woman in the moon), 1929

16. **Bert Hardy**, *Strand cigarette advertisement*, 1959

17. **Fredrik Carl Störmer**, *Scientific photograph: aurora borealis*, 1917

18. **Unknown photographer**, *Scientific photograph: comet*, ca. 1920

19. **Unknown photographer**, *USA NASA satellite photograph of the moon's surface, craters*, 1960s

20. **Unknown photographer**, *Study of central Asians in traditional costume*, 1896

21. **Unknown photographer**, *Scientific photograph: aurora borealis*, 1919

22. **Unknown photographer**, *Scientific photograph: aurora borealis*, 1919

23. **Unknown photographer**, *China: mendicant. "Tientsin,"* late 19th century

24. **Unknown photographer**, *Scientific photograph: 33 comet*, n.d.

25. **Unknown photographer**, *Scientific photograph: moon surface*, 1920s

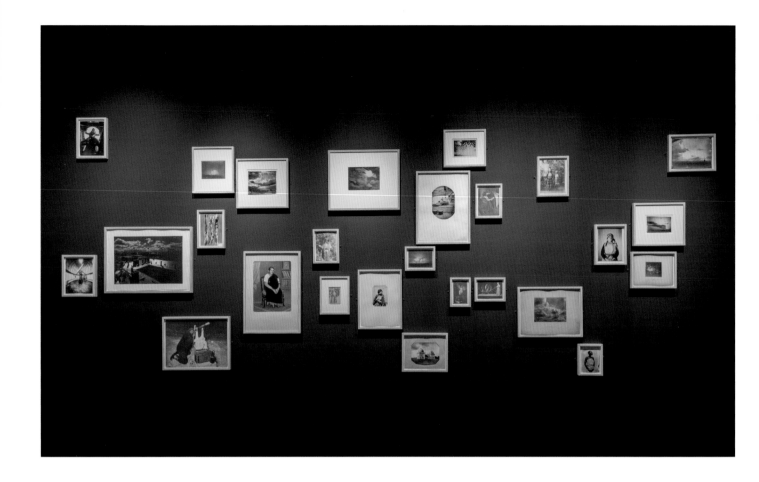

Archive of Modern Conflict, *Collected Shadows*, 2012

01. **Willi Ruge**, *World record parachute jump*, 1932

02. **Unknown photographer**, *Observatory, Oxford, OH*, ca. 1900

03. **Boris Smelov**, *Rooftops in St. Petersburg*, ca. 1980

04. **Unknown photographer**, *Cumulus humilis*, 1870s

05. **Jaroslav Rössler**, *Abstract composition*, 1927

06. **George Herbert Ponting**, *Charles Wright, Scott's Terra Nova expedition*, 1911

07. **Unknown photographer**, *Cumulus mediocris in the Campania*, ca. 1855

08. **Unknown photographer**, *Indian woman*, ca. 1950

09. **A. Taupin**, *Stratocumulus translucidus*, ca. 1860

10. **Edward Curtis**, *Kominaka dancer*, ca. 1900

11. **René Barthélemy**, *A belinograph image*, 1930

12. **Unknown photographer**, *Altocumulus floccus*, ca. 1890

13. **Paul-Émile Miot**, *Mi'kmaq servant girl photographed on the quarter deck of the Ardent*, 1857

14. **Unknown photographer**, *Cumulus mediocris in the Campania*, ca. 1855

15. **Paul-Émile Miot**, *Mik'kmaq woman, Newfoundland*, ca. 1859

16. **Unknown photographer**, *Observatory, Oxford, OH*, ca. 1900

17. **Clarence H. White**, *Open door*, ca. 1900

18. **Frank Coster**, *Spirit photograph*, ca. 1890

19. **Unknown photographer**, *The art of spinning*, ca. 1890

20. **Unknown photographer**, *Study of central Asians in traditional costume*, 1896

21. **Unknown photographer**, *Cloud study, Paris*, 1883

22. **J. Audemos**, *African Congo: ethnographic study*, 1904

23. **Unknown photographer**, *Study of central Asians in traditional costume*, 1896

24. **Carlo Baldessare Simelli**, *Cloud Study*, ca. 1870s

25. **Unknown photographer**, *Scientific photograph: cloud study*, 1880s

26. **Carlo Baldessare Simelli**, *Cloud Study, Near Rome*, 1880s

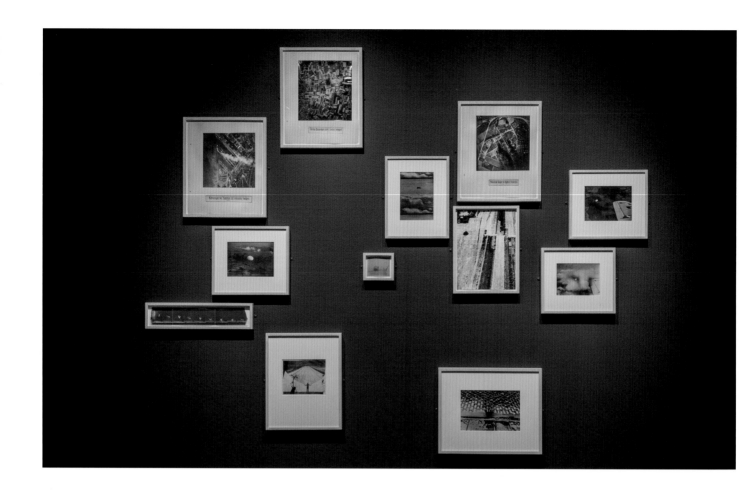

Archive of Modern Conflict, *Collected Shadows*, 2012

01. **Étienne-Jules Marey**, *Bird in flight*, ca. 1882

02. **Willi Ruge**, *How will I become a parachutist?*, 1931

03. **Unknown photographer**, *The Rotterdam–Delft main road*, 1940

04. **Unknown photographer**, *The Rotterdam–Delft main road*, 1940

05. **Willi Ruge**, *World record parachute jump*, 1932

06. **Unknown photographer**, *Clock, dog, and carriage*, ca. 1890

07. **Willi Ruge**, *World record parachute jump*, 1932

08. **Unknown photographer**, *The Rotterdam–Delft main road*, 1940

09. **Mario Giacomelli**, *Landscape*, ca. 1973–76

10. **Humphrey Jennings**, *Cobbled road and pavement*, ca. 1938

11. **Unknown photographer**, *Parachute*, 1940s

12. **Unknown photographer**, *Parachute*, 1940s

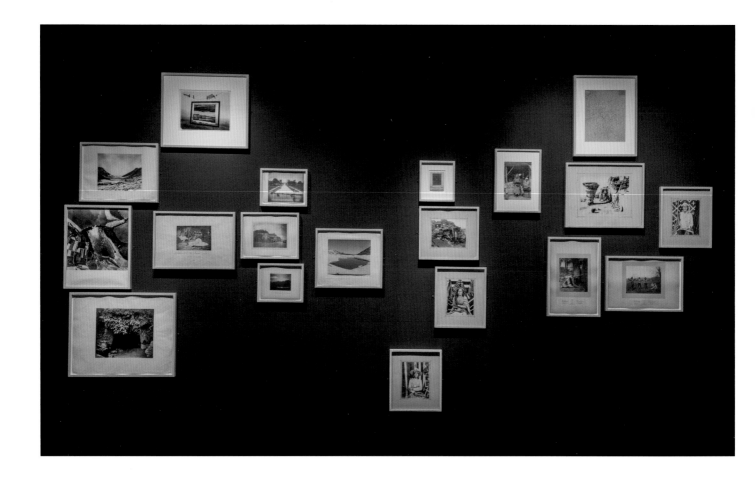

Archive of Modern Conflict, *Collected Shadows*, 2012

01. **John Claude White**, *Chongu, Tibet*, 1904

02. **Royal Air Force**, *Möhne Dam after attack*, 1943

03. **Robert Macpherson**, *Cloaca Maxima, Rome*, 1858

04. **Robert Frank**, *Paysage pour mon ami*, 1974

05. **Unknown photographer**, *Puit artésian de Sidi Amran*, 1859

06. **J. Carolus**, *Inondation de 19 Mars 1876, Quai de la Rapée, Paris*, 1876

07. **Unknown photographer**, *Chicago during the construction of the World's Fair, 65th Street looking east*, 1893

08. **Mathieu-Antoniadi**, *Cumulo Nimbus, 6pm*, 1899

09. **Albert Steiner**, *Early spring mountain/lake scene near St. Moritz*, 1930s

10. **John K. Hillers**, *Moqui, mail rider*, ca. 1879

11. **Ferdinand Quénisset**, *Photograph of the planet Mars*, 1899

12. **John K. Hillers**, *Shrine of the Zuni War Gods*, ca. 1900

13. **John K. Hillers**, *Big Navajo*, ca. 1879

14. **Dimitri Ivanovich Ermakov**, *Baker*, ca. 1895

15. **Ivan Raoult**, *Caucasians: an Imeritan*, ca. 1870

16. **John K. Hillers**, *Dancer's Rock, Wolpi*, 1879

17. **Jules Janssen**, *Observateur de Meudon, cliché du soleil*, 1877

18. **Ivan Raoult**, *Caucasians: Gouriens*, ca.1870

19. **John K. Hillers**, *Navajo shaman*, ca. 1879

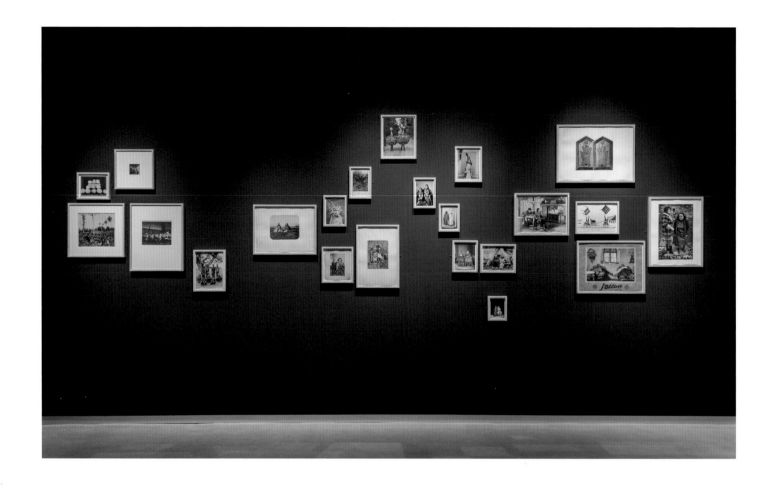

Archive of Modern Conflict, *Collected Shadows*, 2012

01. **F. Pollard**, *Hailstones, natural size*, 1897

02. **James Peace**, *New Hebrides harvest*, 1890

03. **Unknown photographer**, *Church congregation*, ca. 1890

04. **Frances Benjamin Johnston**, *Schoolroom, Washington, DC*, ca. 1899

05. **Unknown photographer**, *Study of Burmese natives*, 1890s

06. **Paul-Émile Miot**, *Wigwams des sauvages de la tribu des Mi'kmaq a Sydney Mine*, 1857

07. **Edward Curtis**, *A Cowichan mask*, 1912

08. **Charles Kroehle**, *Portrait of a man with an Idol*, ca. 1900

09. **Ferdinand Quénisse**, *Photograph of leaves of frost on a pane of glass*, 1908

10. **Paul-Émile Miot**, *Marquesas Islanders with Tiki*, 1870

11. **Maxwell R. Hayes**, *Duk-Duk members*, 1964

12. **Unknown photographer,** *Nepalese women*, ca. 1890

13. **Dimitri Ivanovich Ermakov**, *Georgian costumes*, 1880s

14. **Unknown photographer**, *Study of central Asians in traditional costume*, 1896

15. **Dimitri Ivanovich Ermakov**, *Georgian patriarch with wife*, ca. 1880

16. **Norman Caple**, *North-west coast, British Columbia*, ca. 1894–95

17. **Unknown photographer**, *circle of Dimitri Ivanovich Ermakov, Georgian patriarch and his wife*, 1880s

18. **Roger Kahan**, *Michèle Morgan and Jean Gabin in Le Quai des Brumes*, 1938

19. **Bisson Frères**, *Medieval gloves*, 1858

20. **Unknown photographer**, *Ensembles rythmiques et gymnastiques a Pékin*, 1965

21. **Robert Hubert**, *Advertising placard for the re-release of Abel Gance's "J'Accuse,"* 1938

22. **Markéta Luskacová**, *Two women selling teapots and other things off Cheshire Street, London*, 1977

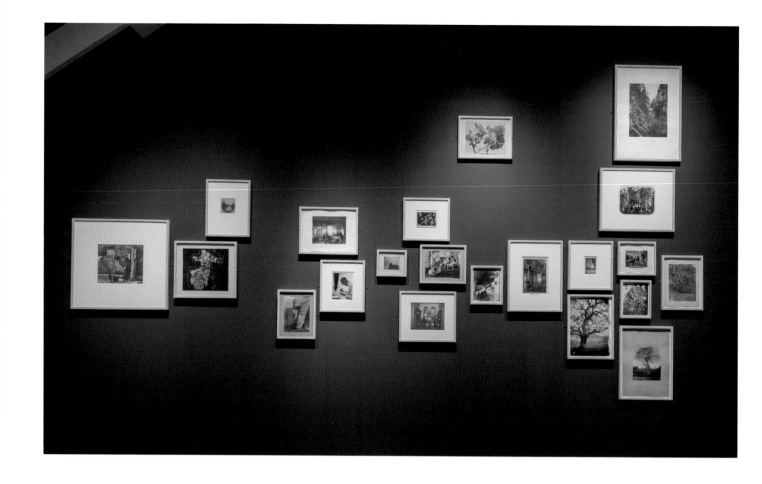

Archive of Modern Conflict, *Collected Shadows*, 2012

01. **Benjamin Brecknell Turner**, *Walter Chamberlain beside the pump at Bredicot*, 1850s

02. **Unknown photographer working for the Belgian Judiciary Service**, *Bloodstain on carpet*, 1881

03. **Unknown photographer**, *Woman on a lonely road*, ca. 1900

04. **Vladimir Bundi**, *Installation II, Bobstoff is hanged, Leningrad*, 1927

05. **Louis Vignes**, *Interior view of a Beirut Residence. Taken during an expedition with Duc de Luynes*, 1860s

06. **Alexandre Khlebnikov**, *Self-portrait with a microscopic camera*, 1950

07. **Unknown photographer**, *Forked lightning over a house*, ca. 1880

08. **Ferdinand Quénisset**, *Photograph of leaves of frost on a pane of glass*, 1906

09. **Unknown photographer**, *A medical doctor giving Faradisation with a Hertz electrostatic machine*, ca. 1896

10. **Vladimir Bundi**, *Art in an apartment, Leningrad*, 1927

11. **Louis Ollivier**, *Feuilles de chou frise, no. 296,* ca. 1900

12. **Eugene Atget**, *The photographer's kitchen,* ca. 1910

13. **Josef Sudek**, *Pillar and tree (view from the studio window),* ca. 1953

14. **Igor Kotelnikov,** *First snow, Tashkent,* 1928

15. **William**, *2nd Earl of Craven, Oak tree,* ca. 1855

16. **Paul Émile Miot**, *Spruce forest, Newfoundland,* 1857

17. **Léon Gérard**, *Passage du Splugen, Suisse,* 1859

18. **Robert Burrows**, *Vegetation in Foxhall Road, Ipswich,* 1860

19. **Charles Nègre**, *Study of plants,* 1865

20. **Constant Alexandre Famin**, *Forêt de Fontainebleau: Le rageur,* ca. 1870

21. **Unknown photographer**, *A hat in the forest,* 1890

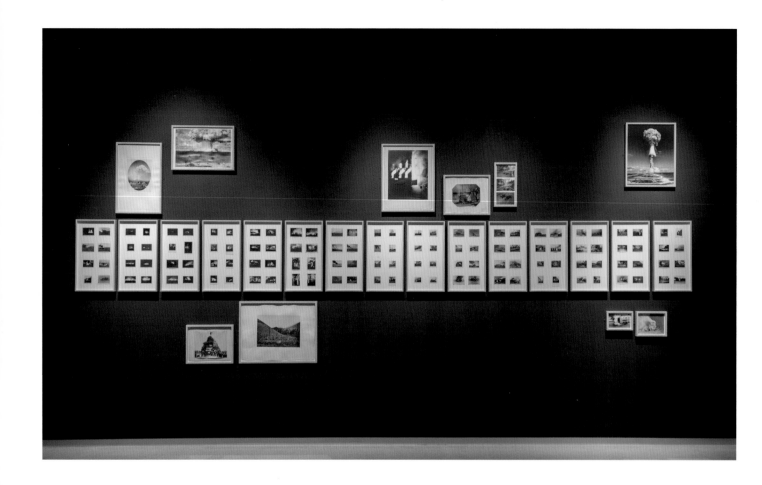

Archive of Modern Conflict, *Collected Shadows*, 2012

01. **Unknown photographer**, *Snapshot on the Eastern Front, World War II*, ca. 1942

02. **Alphonse Bernoud**, *Eruption of Vesuvius*, 1872

03. **Department of Defense**, *Operation Crossroads, Baker atomic bomb test, Bikini Atoll*, 1946

04. **Scott & Wilkinson**, *A bonfire constructed to celebrate the relief of Mafeking*, 1900

05. **Paul Berthier**, *After the eruption of Mount Etna*, 1865

In 1975, Sultan and Mandel made their first investigations of a whole range of public and private archives storing photographs made as documentation of research projects, scientific procedures, federal and governmental activities. . . . At first they were presented with an endless stream of confident, almost transcendentally resonant photographic documentation of outer space and controlled particle explosions, the kind of photographs that they were not looking for. But, occasionally, they would find an image that was neither romantic nor spectacular, but inherently strange.

Charlotte Cotton

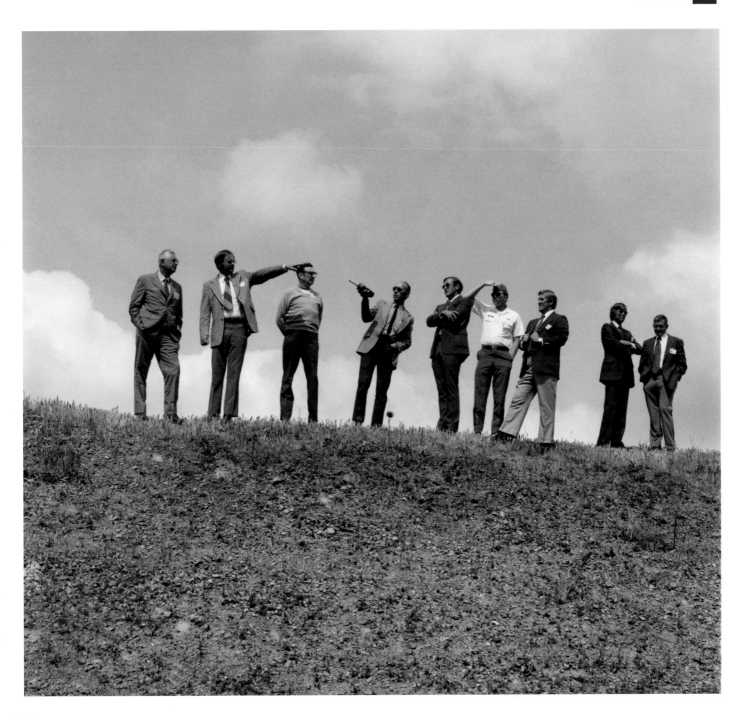

Larry Sultan and Mike Mandel, *Evidence*, 1977

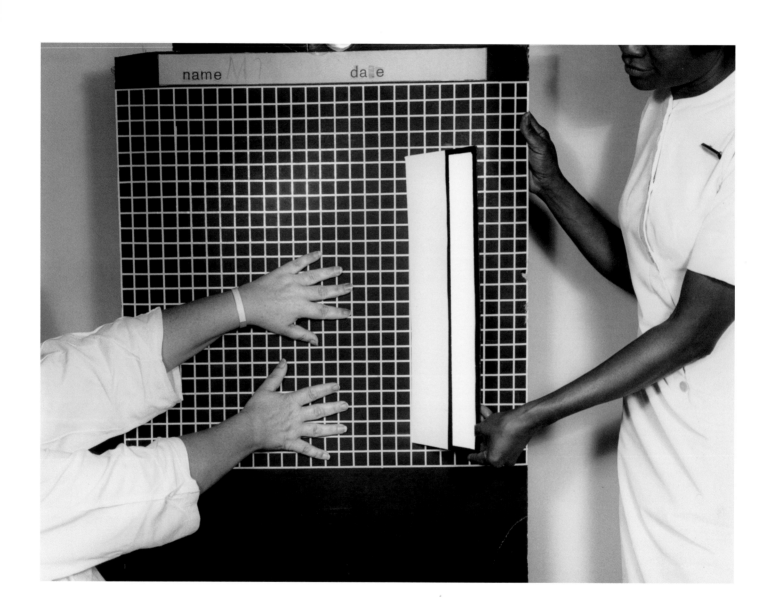

Larry Sultan and Mike Mandel, *Evidence*, 1977

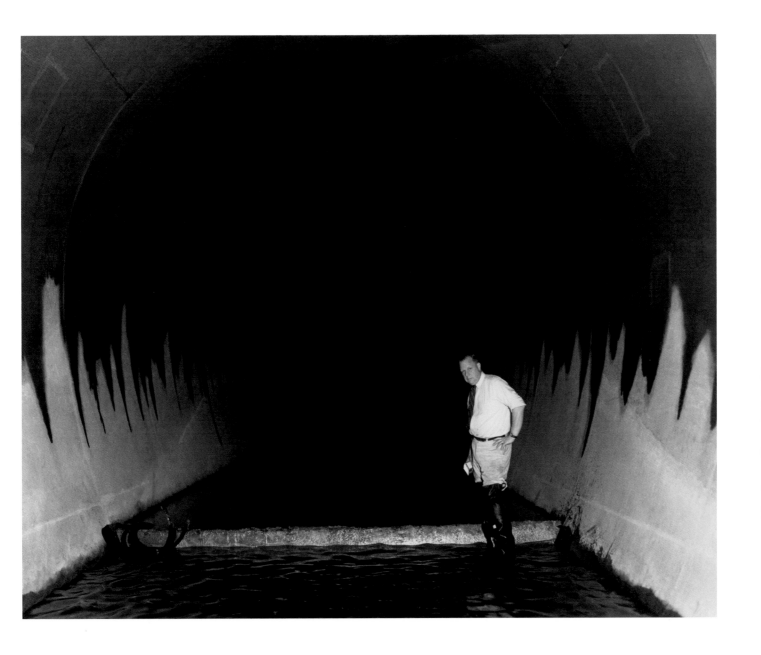

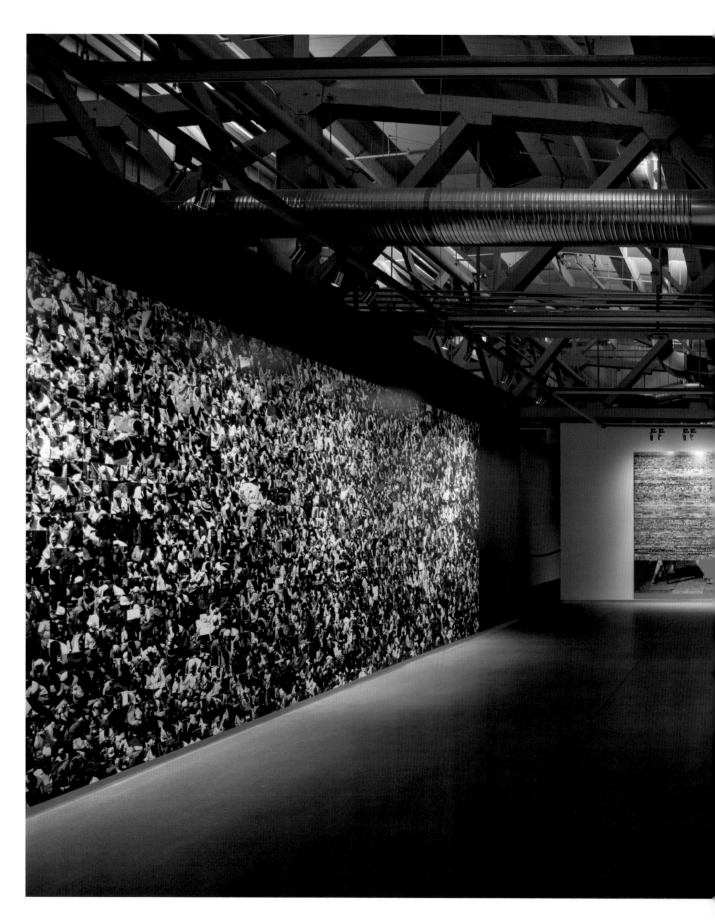

Left and right:
Rashid Rana, *Crowd*, 2013

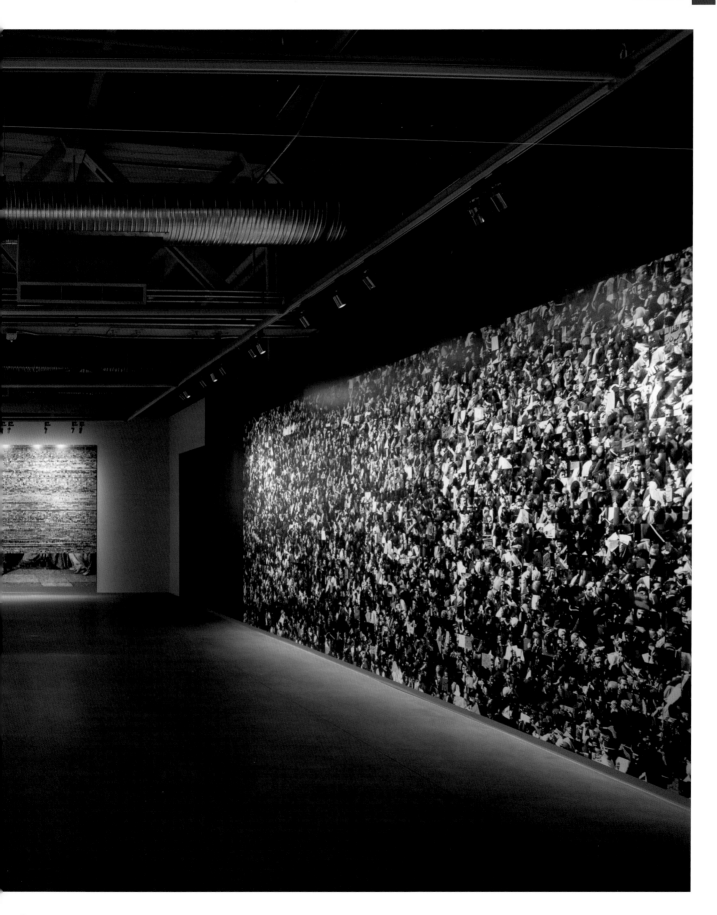

Center:
Rashid Rana, *Language V*, 2011–12

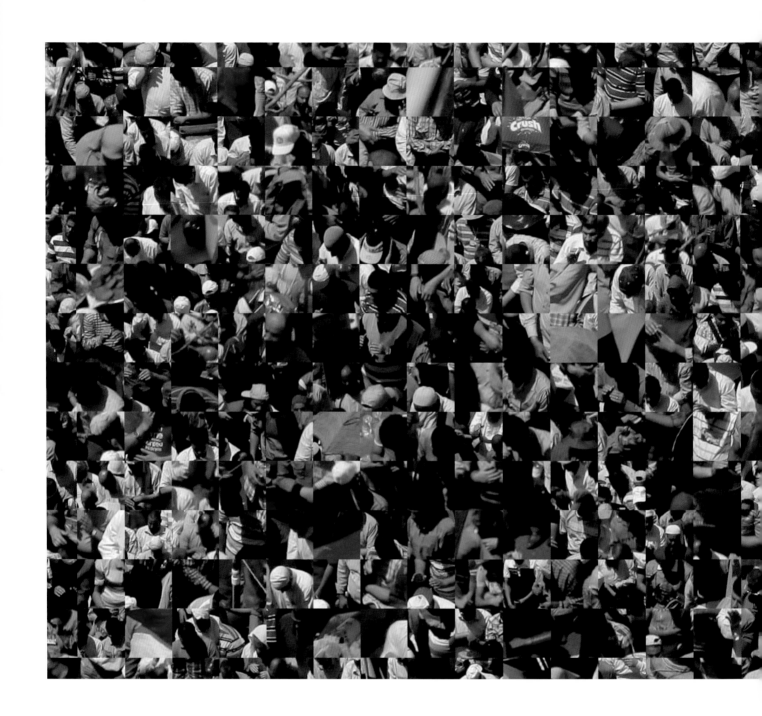

Rashid Rana, *Crowd*, 2013 (detail)

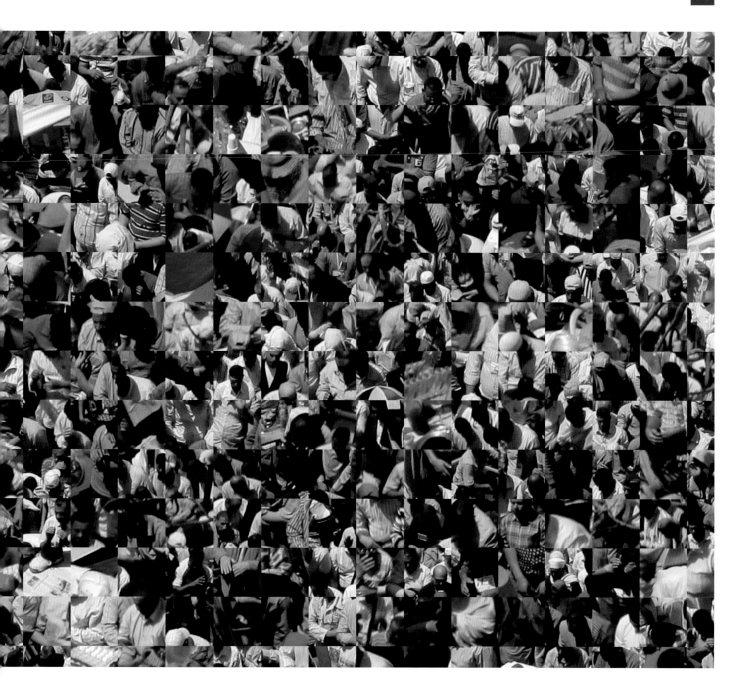

I made a conscious decision to borrow everything—starting from the images to the title of the work. There is nothing original to begin with, but strangely, by using this tactic my work became uniquely mine and thus original. I do not think it is so much to do with a greater reality and un-reality, but more to do with reinventing through reality—and to show a kind of paradox that we fail to notice even though it is what makes us who or what we are.

Rashid Rana

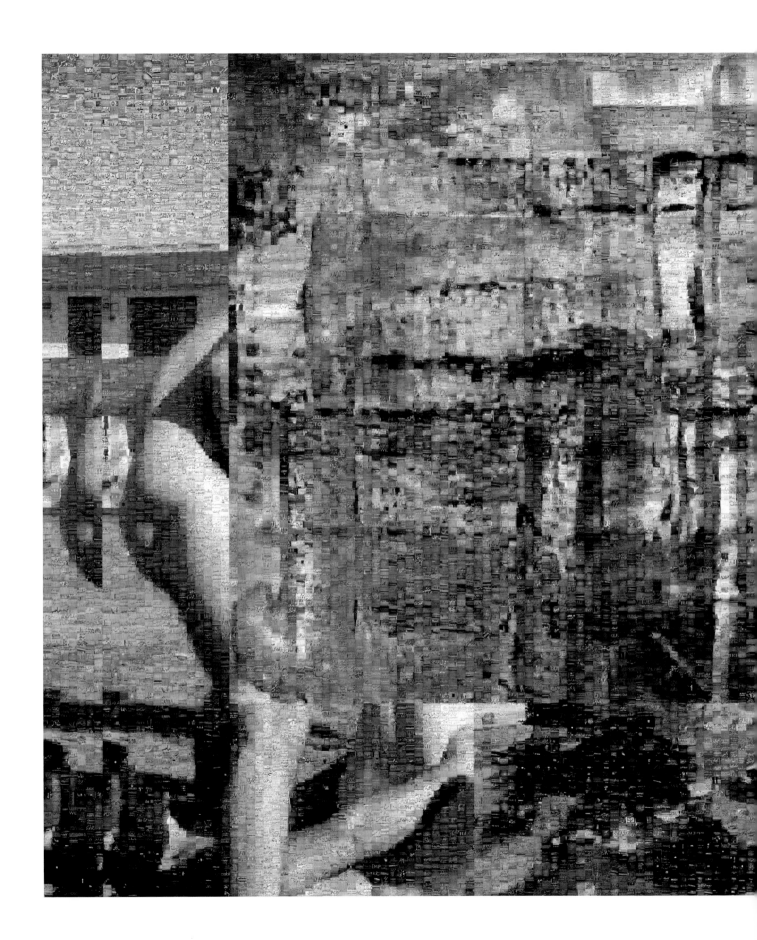

Rashid Rana, *Language IX*, 2011–12

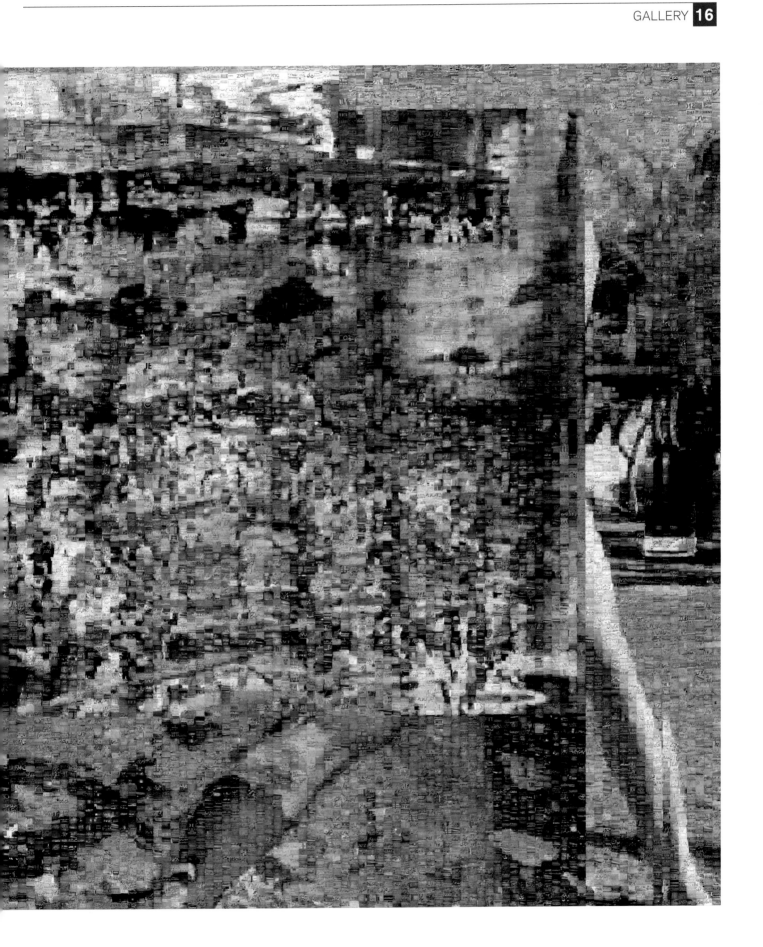

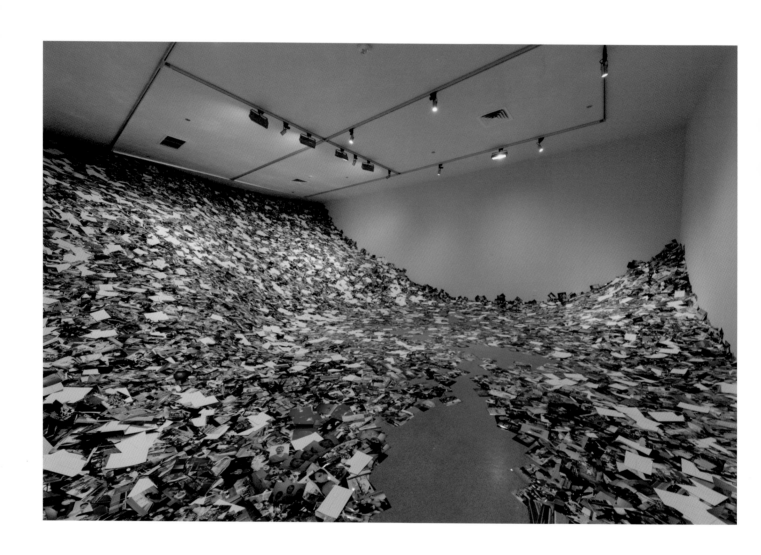

Erik Kessels, *24 HRS in Photos*, 2013

Photography nowadays is not comparable to what it was before. We live in a new age of imagery, a new renaissance of photography. People nowadays see more images before lunch than a person in the nineteenth century saw in his whole life. This glut is in large part the result of image-sharing sites like Flickr, networking sites like Facebook, and picture-based search engines. By printing all the images uploaded in a twenty-four-hour period, I visualize the feeling of drowning in representations of other peoples' experiences.

Erik Kessels

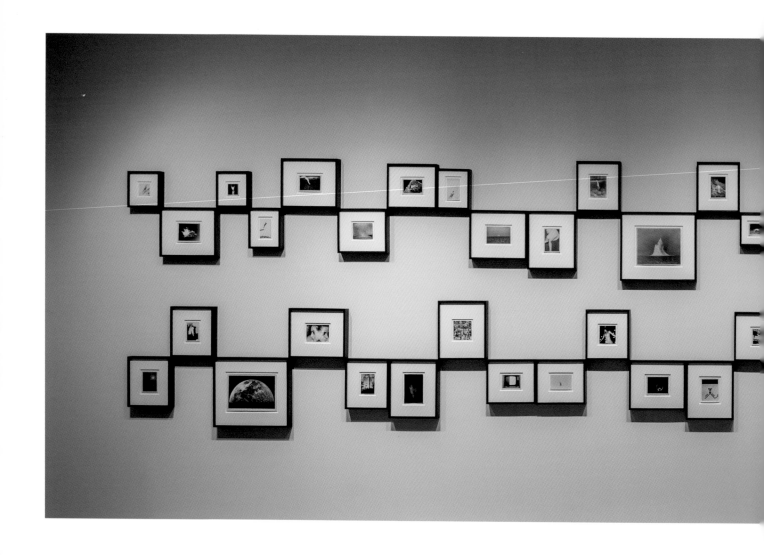

Melissa Catanese, *Dive Dark Dream Slow*, 2012

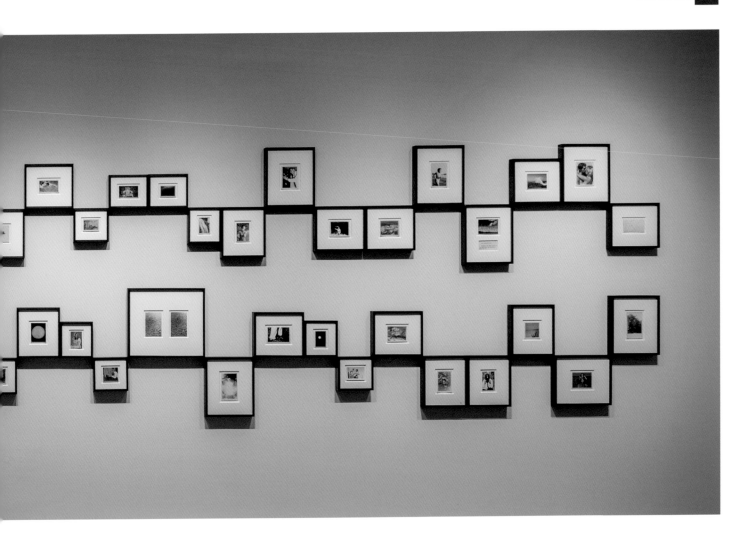

Dive Dark Dream Slow is rooted in the mystery and delight of the "found" image and the "snapshot" aesthetic, but pushes beneath the nostalgic surface of these pictures, re-reading them as luminous transmissions of anticipation, fear, and desire. Selected from the vernacular photography collection of Peter J. Cohen—a massive curated archive of more than 20,000 photographs—*Dive Dark Dream Slow* explores an alternate reading of the collection, drifting away from simple typology into something more personal, intuitive, and openly poetic. Like an album of pop songs about a girl (or a civilization) hovering on the verge of transformation, this work cycles through overlapping themes of violence and tenderness, innocence and experience, all of which are charged with psychic longing and apocalyptic comedy.

Melissa Catanese

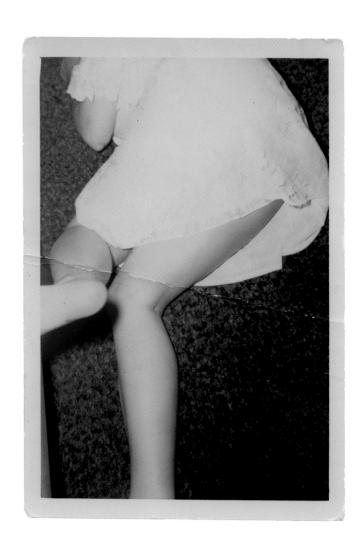

Melissa Catanese, *Dive Dark Dream Slow*, 2012

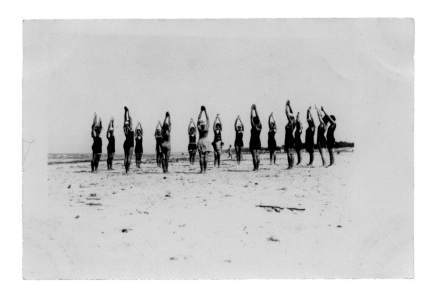

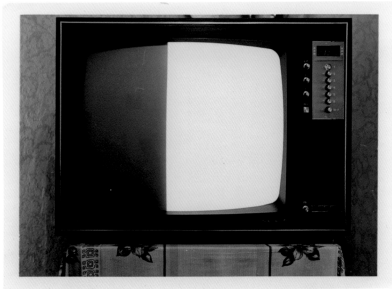

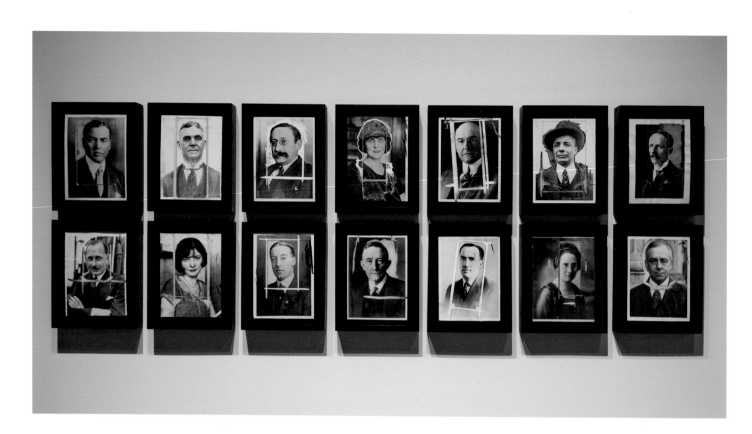

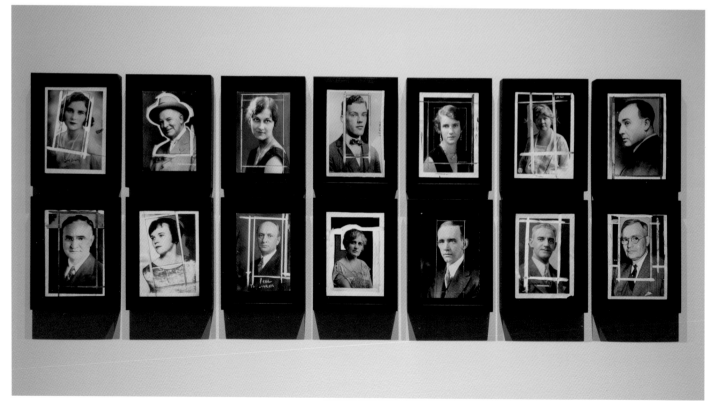

Unknown photographers, Press photos: portraits, 1920s

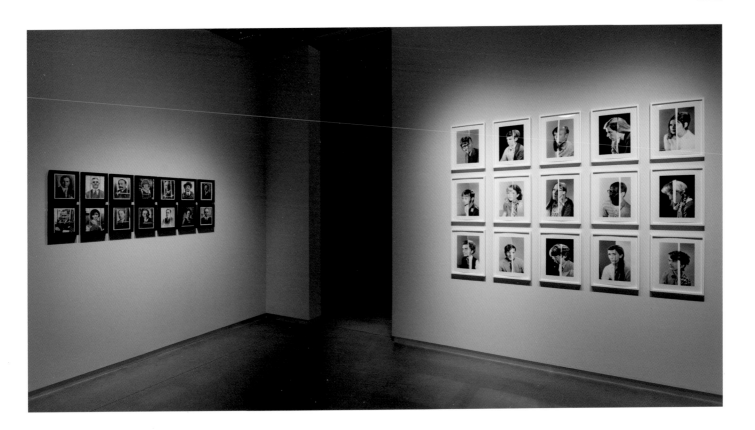

Like all of Schmid's work, *Photogenetic Drafts* both reveals and interrogates the nature of photographic practice in daily life, literally dissecting the work of every-day portrait photographers and their middle-class, first world-clients. At the same time, a close look at the individual images quickly leads to speculations about the people in them. Why, these images ask, is memory so important to us, and so linked to seeing and self-image? Why do we seek to capture and freeze in time the faces of our children, our parents, our lovers, and ourselves? Is what we look like who we really are, and if not, who else might we be?

John S. Weber

Right:
Joachim Schmid, *Photogenetic Drafts*, 1991

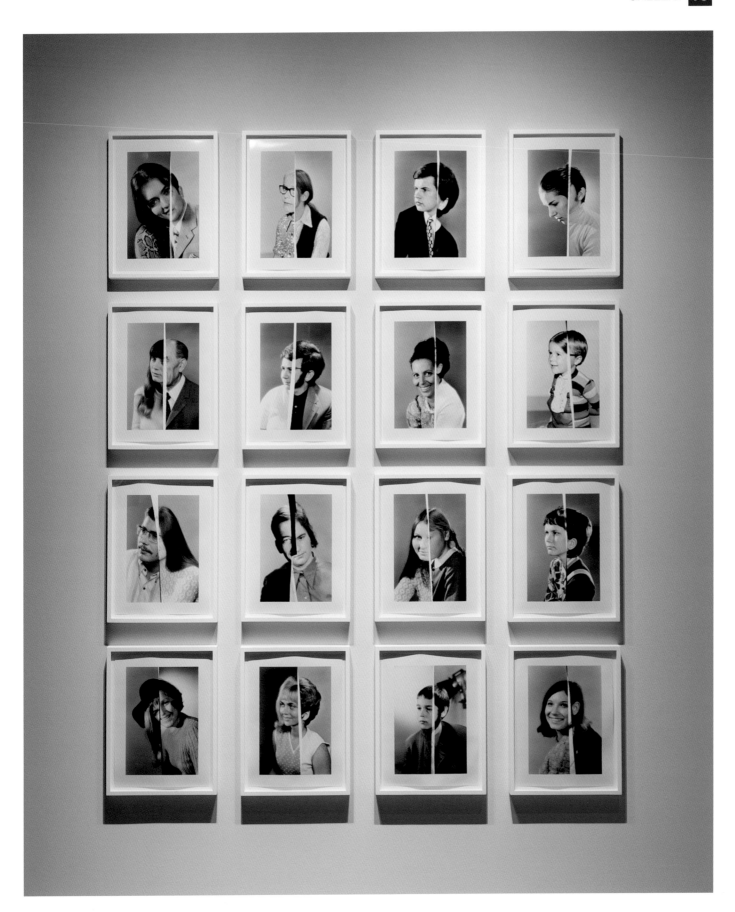

Joachim Schmid, *Photogenetic Drafts*, 1991

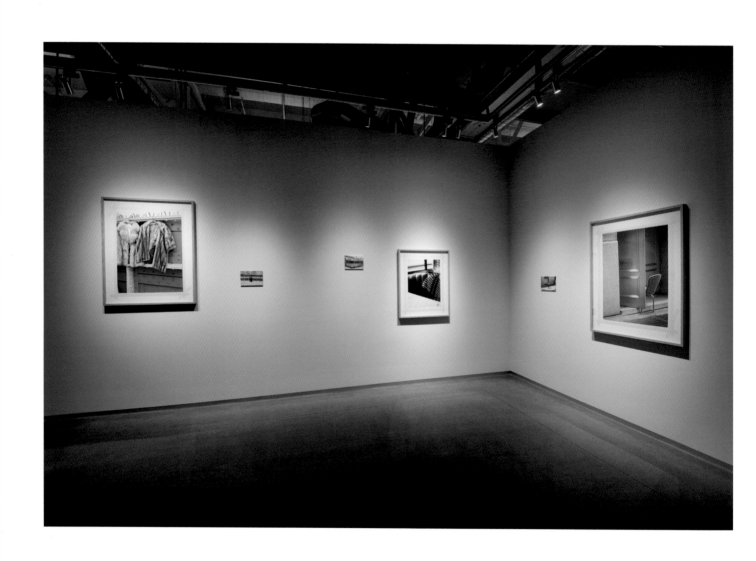

Left to right:
Viktoria Binschtok
World of Details (coats + couple), 2011
World of Details (diner seat + diner), 2012
World of Details (golden door + cop), 2011

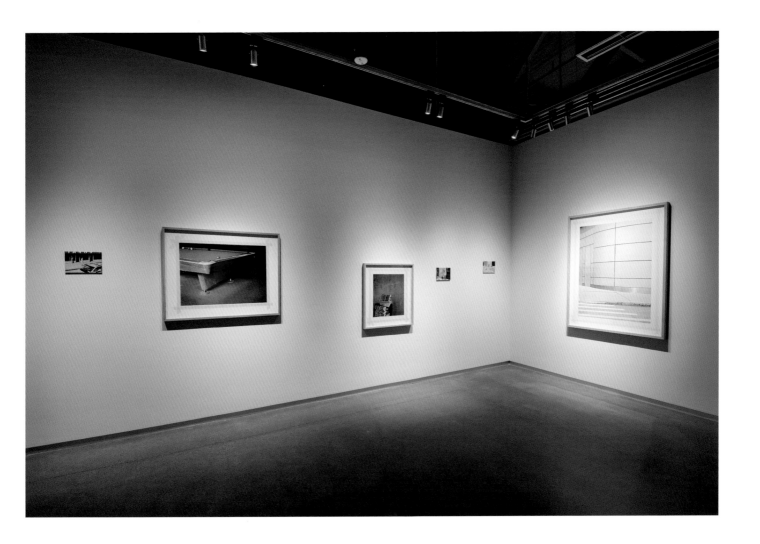

Left to right:
Viktoria Binschtok
World of Details (billiardtable + billiards), 2011
World of Details (blind + news), 2012
World of Details (round corner + crossing), 2012

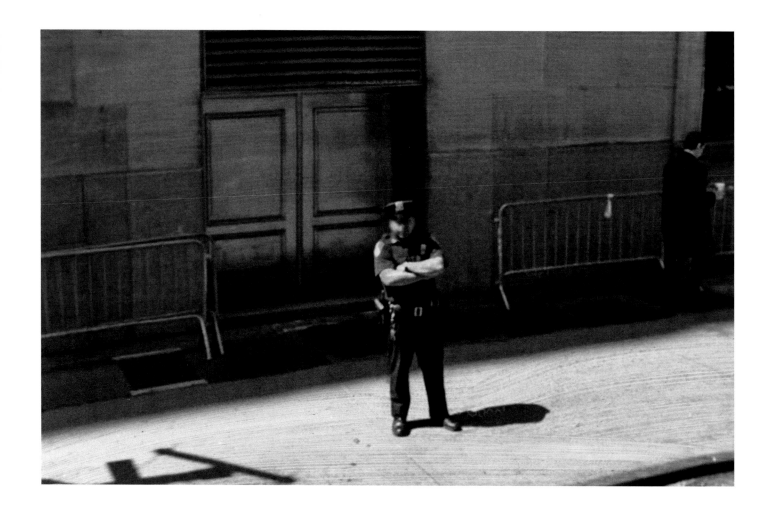

Every time and generation has its own new sources of information. Today, for instance, with its pool of worldwide images, Google Street View is a kind of visual quarry that artists dig around in, among them Viktoria Binschtok. She begins each of her works by appropriating images from this source. Her method is that of a two-part search: both for a fitting image to work from and an after-image to be finally realized on location. In this respect, a before-and-after effect exists not only in content, but also in terms of time. Yet both images, which Binschtok later arranges into an unequal diptych, seem removed from time, contemporary in a timeless way.

Matthias Harder

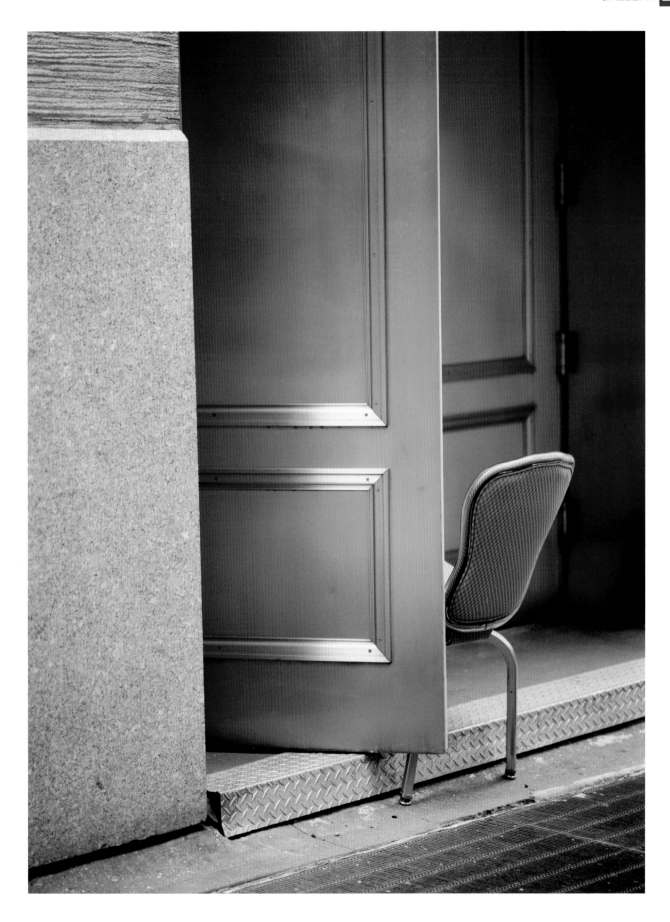

Viktoria Binschtok, *World of Details (golden door + cop)*, 2011

Pier 24 Photography would like to acknowledge the following individuals and lenders for their assistance in making this exhibition possible.

A Palazzo Gallery, Brescia
Maurizio Anzeri
Archive of Modern Conflict, London
Jeroen Bijl
Marta Boglioli
Mauro Botta
Pierre Brahm
Roland Buschmann
Chemould Prescott Road, Mumbai
Peter J. Cohen
Emma Abdy Collins
Doris Fisher
Foam, Amsterdam
Gagosian Gallery, New York
Stanlee Gatti
Goodman Gallery, Johannesburg
Erik Kessels
KLEMM'S, Berlin
Mike Mandel
Karen McQuaid
Angela Missoni
Margherita Maccapani Missoni
Kelly Padden
Richard Prince
Timothy Prus
Rashid Rana
Elena Rigamonti
Silka Rittson-Thomas
Joachim Schmid
Vito De Serio
Jack Shainman Gallery, New York
Jessica Silverman Gallery, San Francisco
Kelly Sultan
The Estate of Larry Sultan
Hank Willis Thomas
Marcella Trimarchi
Wallspace, New York

This publication would not have been possible without the generous contributions of the Pier 24 Photography volunteer and intern team.

Director:
Christopher McCall

Editor:
Seth Curcio

Editorial Associate:
Allie Haeusslein

Copy Editor:
Amanda Glesmann

Design:
Something in the Universe

Installation Photography:
Charles Villyard

Print Management:
Sprinkel Media

ISBN: 978-0-9839917-5-5
Printed in the United States

Photography Credits:
Richard Prince: © Richard Prince, courtesy Gagosian Gallery, New York; photograph by Rob McKeever / Erik Kessels: © Erik Kessels, courtesy of the artist / Matt Lipps: © Matt Lipps, courtesy of the artist and Jessica Silverman Gallery, San Francisco / Maurizio Anzeri: © Maurizio Anzeri, courtesy of the artist / Daniel Gordon: © Daniel Gordon, courtesy Wallspace, New York / Studio of Bert Hardy: © Studio of Bert Hardy, courtesy the Archive of Modern Conflict, London / Larry Sultan and Mike Mandel: © Larry Sultan and Mike Mandel, courtesy Mike Mandel and the Estate of Larry Sultan / Rashid Rana: © Rashid Rana, courtesy of the artist / Melissa Catanese: © Melissa Catanese, courtesy Peter J. Cohen / Joachim Schmid: © Joachim Schmid, courtesy of the artist / Viktoria Binschtok: © Viktoria Binschtok, courtesy KLEMM'S, Berlin

Pier 24, The Embarcadero
San Francisco, CA 94105
p. 415.512.7424
e. info@pier24.org